IMPRESSIONS OF GIVERNY

MONET'S WORLD

IMPRESSIONS OF GIVERNY

MONET'S WORLD

Photographs and Text by Charles Weckler

Harry N. Abrams, Inc., Publishers, New York

For Kristina

Editor: Eric Himmel
Designer: Darilyn Lowe

Library of Congress Cataloging-in-Publication Data

Weckler, Charles.
 Impressions of Giverny: Monet's world / photographs and text by
 Charles Weckler.
 p. cm.
 ISBN 0–8109–1132–9
 1. Monet, Claude, 1840–1926—Homes and haunts—France—Giverny.
2. Gardens—France—Giverny. I. Title.
ND553.M7W28 1990
759.4—dc20 89–18064
 CIP

Published in 1990 by Harry N. Abrams, Incorporated, New York.
All rights reserved. No part of the contents of this book
may be reproduced without the written permission of the publisher

A Times Mirror Company

Printed and bound in Japan

CONTENTS

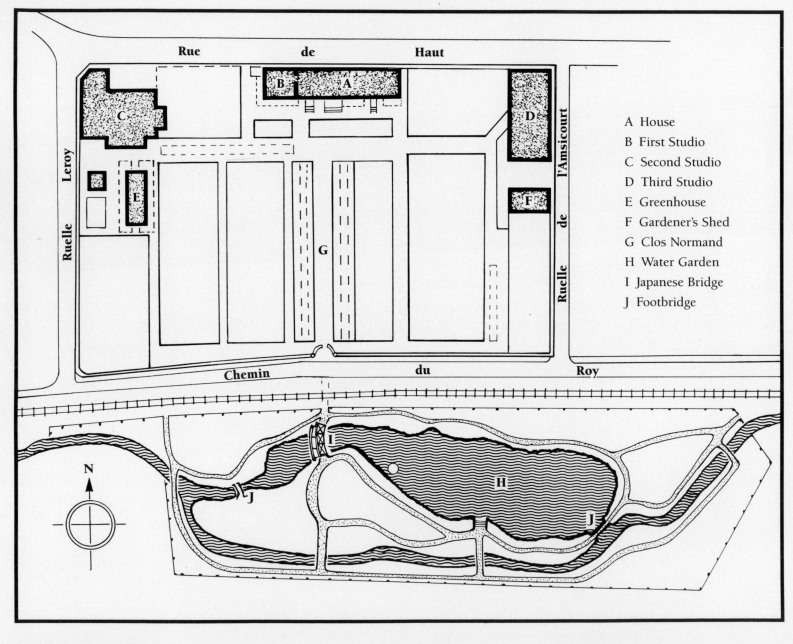

A House
B First Studio
C Second Studio
D Third Studio
E Greenhouse
F Gardener's Shed
G Clos Normand
H Water Garden
I Japanese Bridge
J Footbridge

Giverny in Monet's Lifetime

GIVERNY

CLAUDE MONET WAS forty-two in early April, 1883. With burgeoning debts and only a month left on the lease of his house at Poissy, brooding over past misfortunes, he was in desperate straits. Anxious about the future—his household numbered ten, not including servants—he rode the little trains that crisscrossed Normandy, in search of a home. Between Vernon and Gasny, against the hills on the east bank of the Seine, he discovered the tiny village of Giverny. There, a short forty miles northwest of the bright lights of Paris, he found a house where he lived and painted for forty-three years.

The move from Poissy to Giverny took ten days. Before it was over, Monet had to wire his dealer, Durand-Ruel, for cash to pay the train fare for Alice Hoschedé, the companion he was to marry in 1892, and the children still at Poissy. The house was built by a rich merchant from Guadeloupe, one Louis-Joseph Singeot, who had retired and moved across the Seine to Vernon. Singeot put his love of the Caribbean into the style of the house, whose pink walls were a mixture of crushed brick and white stucco. The somewhat exotic compound was perfect for Monet, who was particularly pleased that there was a good school in nearby Vernon for the children. Eventually, in 1890, with his money problems behind him, he was able to purchase the property. Three years later, he purchased an adjoining piece of land with a small pond. And he set about the creation of the gardens that were the subject of many of his greatest paintings.

Giverny remained in the Monet family until 1966, when it was bequeathed to the Institut de France by Michel Monet, the artist's son. Today, the house and gardens, carefully restored, are open to the public.

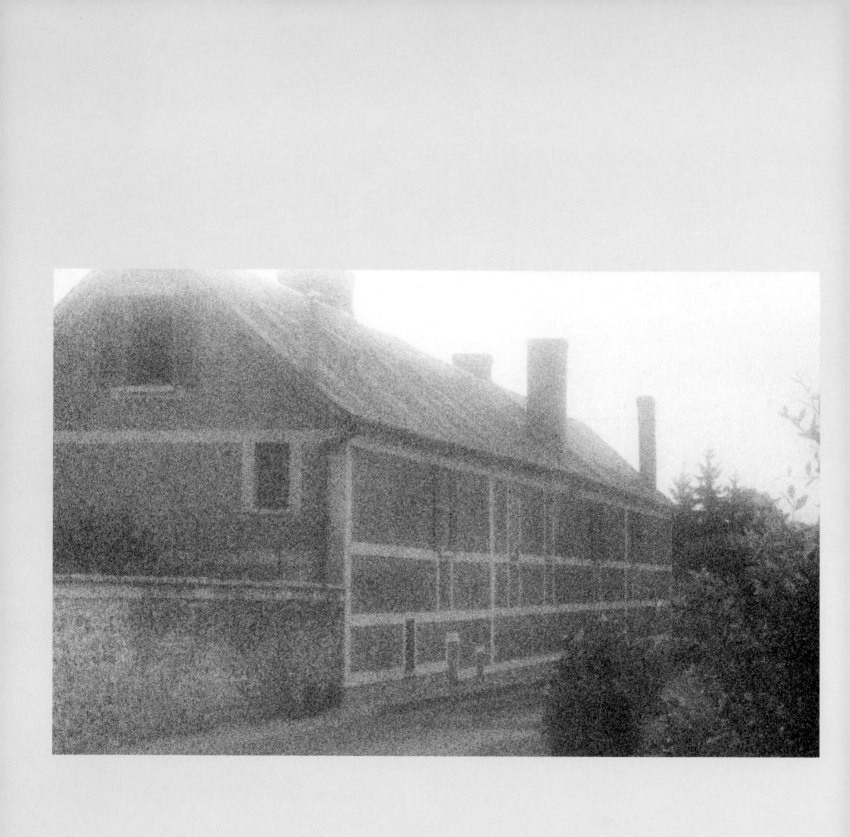

THE HOUSE

GIVERNY WAS EQUALLY a place to work and a place to live. At first, Monet used the dirt-floored barn at the western end of the long house as his studio. When he built a separate studio, called the second studio, around 1897, the old studio became more of a salon. The painter would entertain visitors to Giverny in this intimate and tranquil setting, under the gaze of Rodin's bust of Monet, discussing art and artists. A third studio was begun in 1914 and completed two years later. But in a larger sense, all of Giverny was the painter's studio.

The heart of the house is the cheery, yellow dining room, with a large table that could seat fourteen. Two sideboards hold the yellow and blue dinnerware, designed by Monet and made in Limoges, used for grand occasions. Blue Willow Ware, a French interpretation of a Japanese motif, served for everyday use. Monet's collection of Japanese color woodcuts and Oriental vases decorate the room.

Here, the family and guests gathered for the noon meal. The artist presided with talk of wine, food, and gardening. He was a gourmet but not a great connoisseur of wines. Good food was his major concern, and he demanded the best for his table. Menus were planned sometimes a week in advance, especially during the summer months when Giverny swarmed with children and grandchildren. Then the French windows would be opened wide, and the dining room and garden would become one.

Adjoining the dining room is the blue-and-white-tiled kitchen. Burnished copper pots and pans hang from the wall. On the shelf above them is a row of copper molds in every shape. The large black polished stove in the corner waits for the cook to practice her culinary skills. She, too, had, through the doorway and French window, a view of the garden.

Upstairs are the bedrooms. Above the studio is Monet's bedroom. A large window with a spectacular view of the Clos Normand garden dominates the room. The bed, in which Monet slept from 1883 to 1926, is positioned near the door to Alice's bedroom. It was here, on December 5, 1926, that Monet died. On the other side of the central staircase are the rooms that the children used when they were small. In the attic are the servants' quarters.

Opposite: *The house*

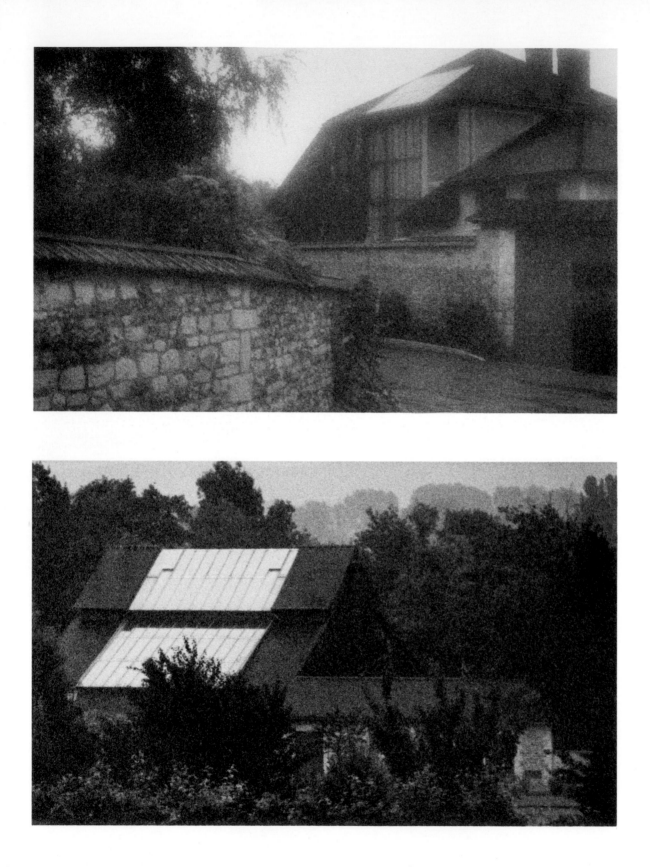

Monet's second studio

Monet's third studio

Opposite:
The library

Overleaf, left:
*The first studio with
Rodin's bust of Monet*

Overleaf, right:
The dining room table

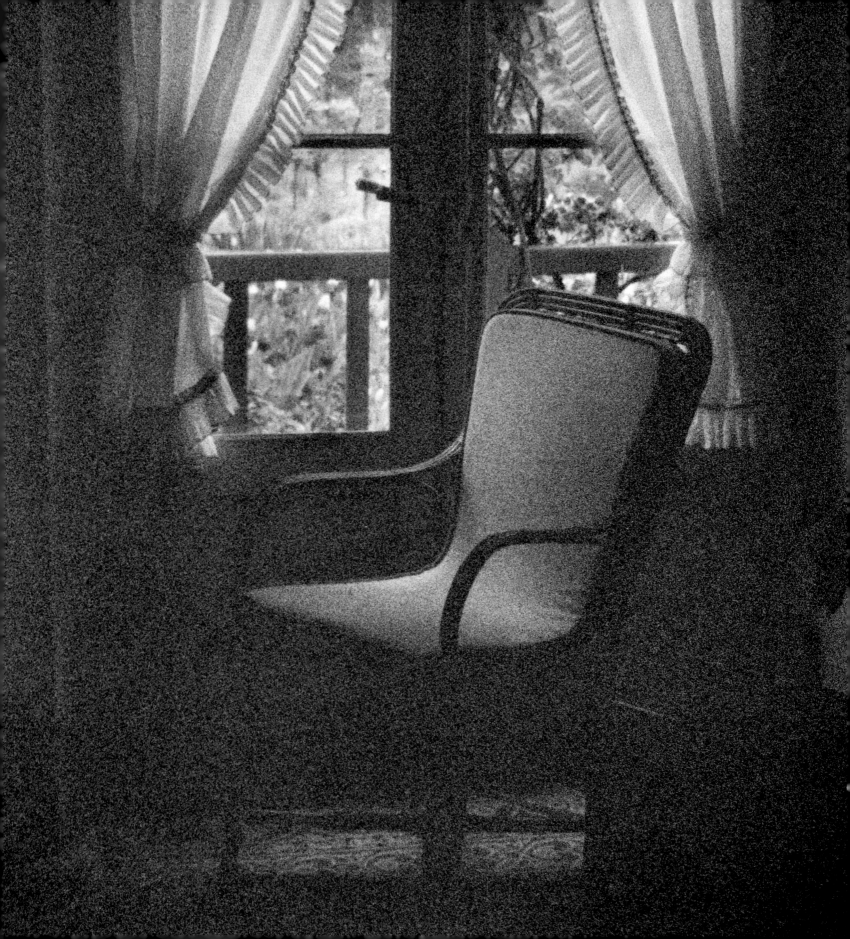

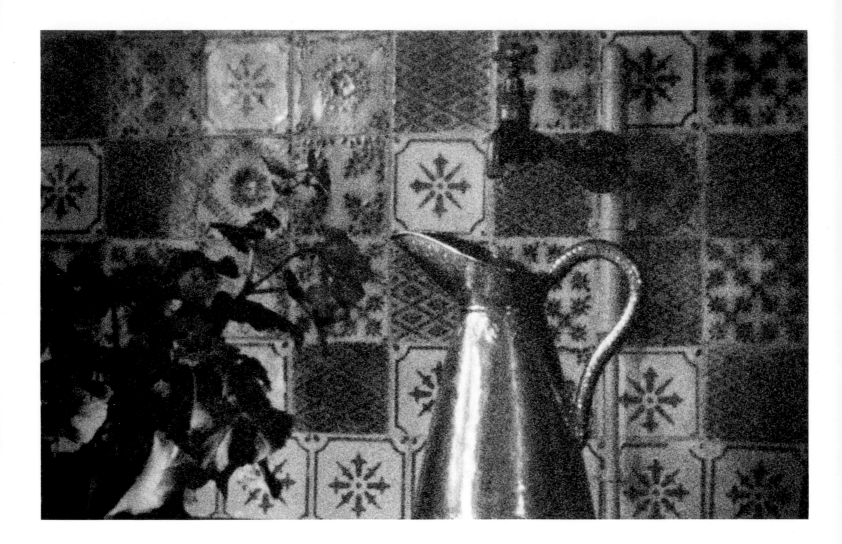

Above and opposite:
The kitchen

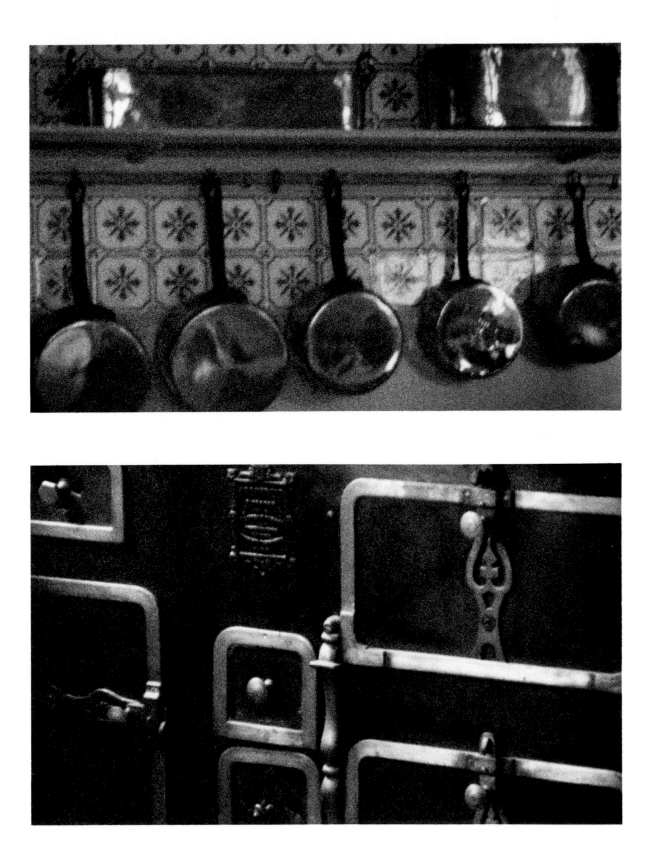

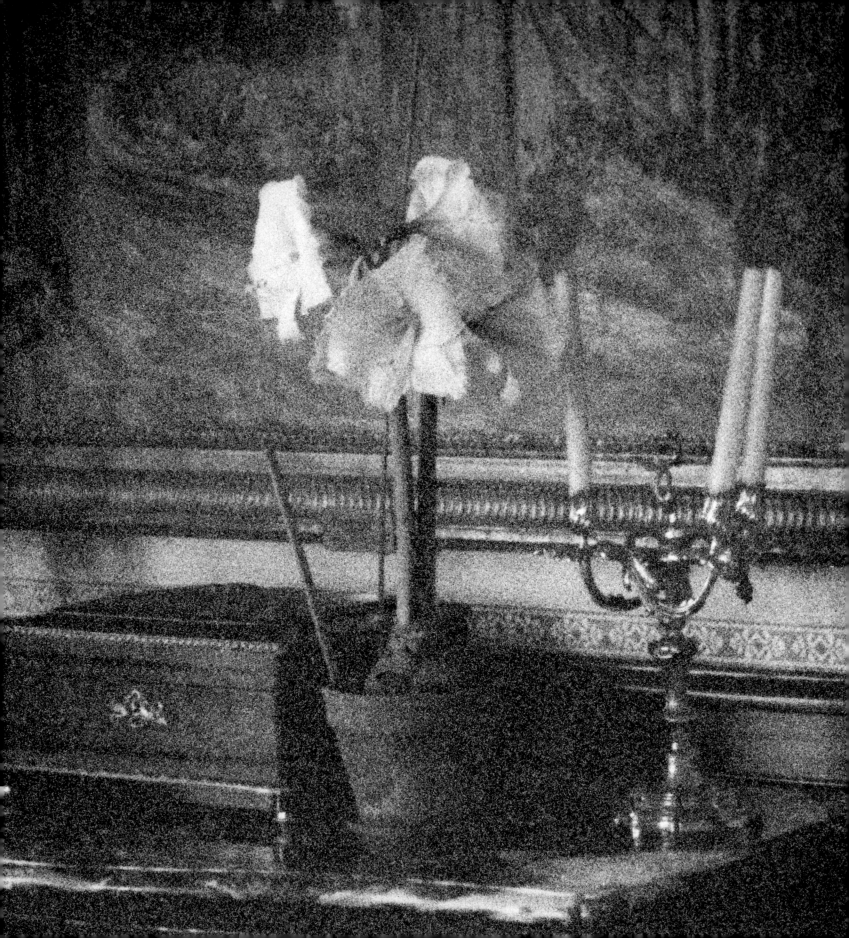

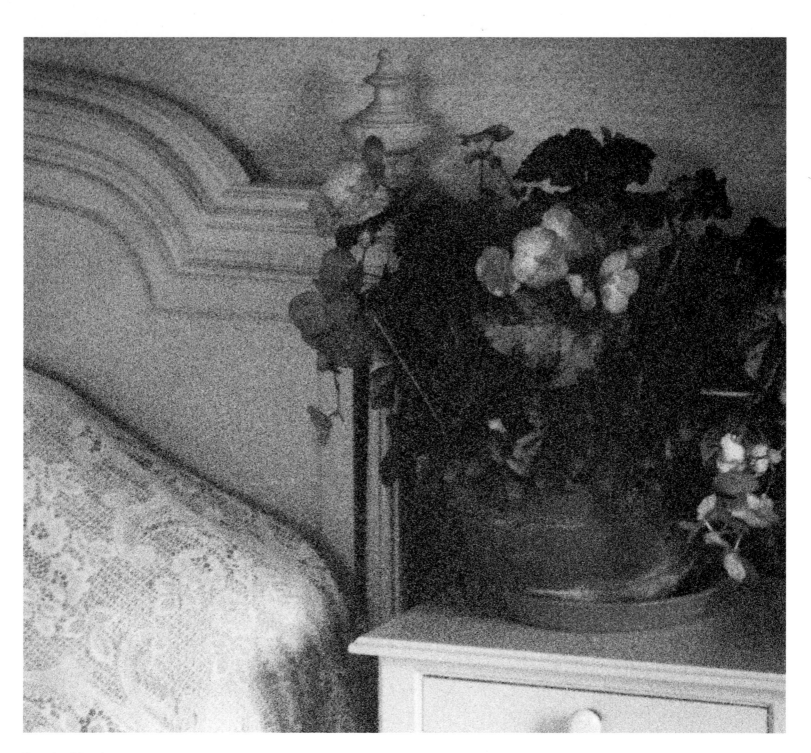

*Begonias, Monet's
bedroom*

Opposite:
*Amaryllis, Monet's
bedroom*

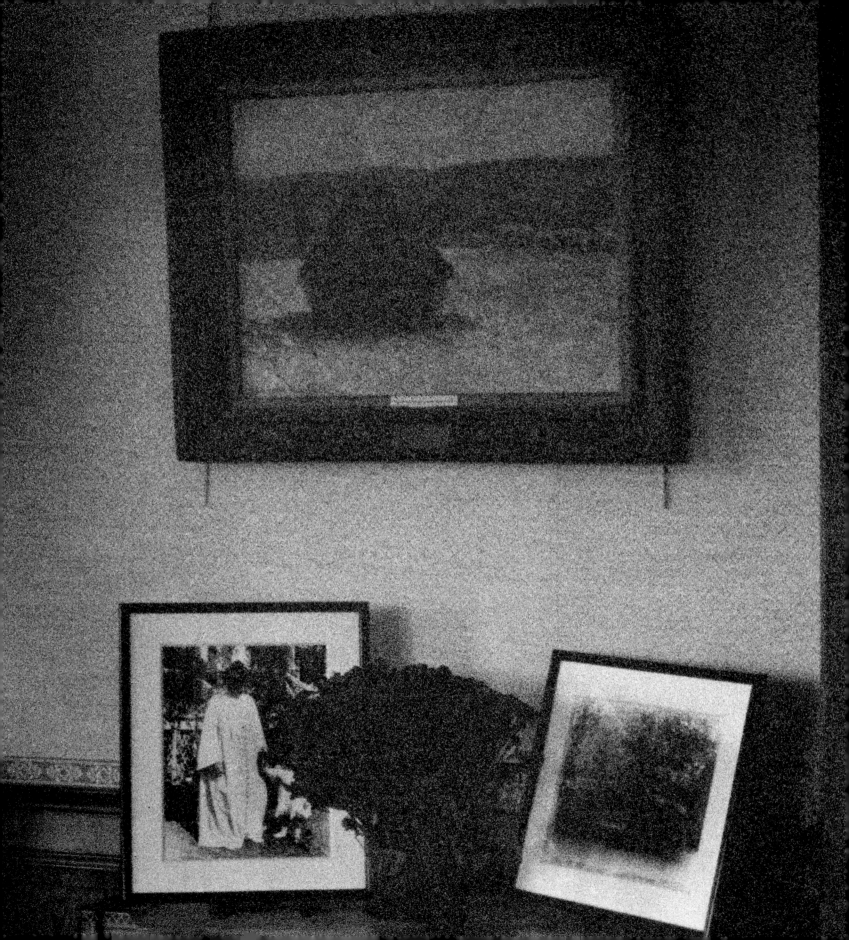

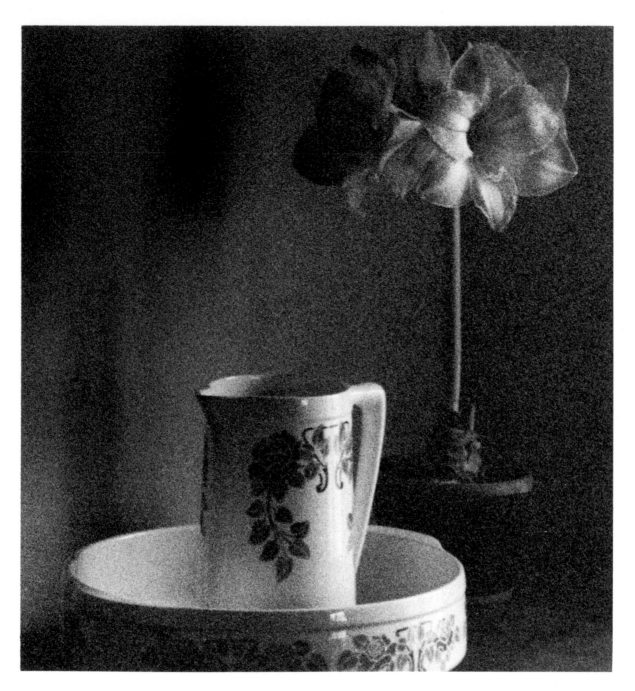

The washroom

Opposite:
Monet's bedroom

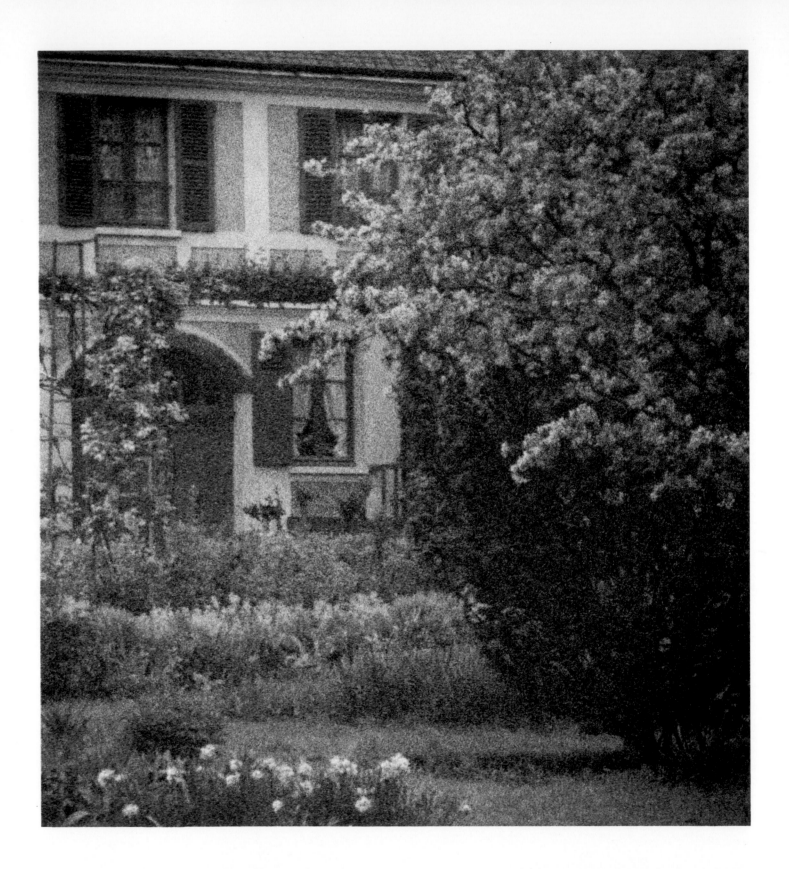

THE
CLOS NORMAND

"I PERHAPS OWE having become a painter to flowers," Monet said at eighty. "My garden is slow work, pursued with love and I do not deny that. What I need most of all are flowers, always, always." To obtain his flowers, Monet converted the walled kitchen garden into a flower garden that would provide blooms from early spring to late autumn, without sacrificing its traditional plan: A wide gravel path, spanned by trellises for roses and bordered by flowerbeds laid out in simple geometric patterns, leads from the road to the front door of the house. Gardening with both annuals and perennials (and calling upon the labor, eventually, of a head gardener and five assistants), Monet was able to produce astonishing coloristic effects. Daffodils and flowering trees closely followed by tulips, azaleas, lilacs, and irises dazzle in the spring. They are followed in summer by brilliant splashes of morning glories, sweet peas, roses, stock, marigolds, zinnias, dahlias, and lilies, and nasturtiums that overrun the path. With autumn come asters, sunflowers, black-eyed Susans, and hollyhocks. Bordering the garden Monet built greenhouses, where orchids and ferns were cultivated. "I am good for nothing," he said, "except painting and gardening."

Monet painted the garden path many times around the turn of the century, especially when construction of the larger lily pond interrupted his work in the water garden. He returned to the Clos Normand toward the very end of his life, when he was almost blind, to make a final series of paintings of the house and path.

Opposite:
The house from the Clos Normand, May

Overleaf:
The garden path, May

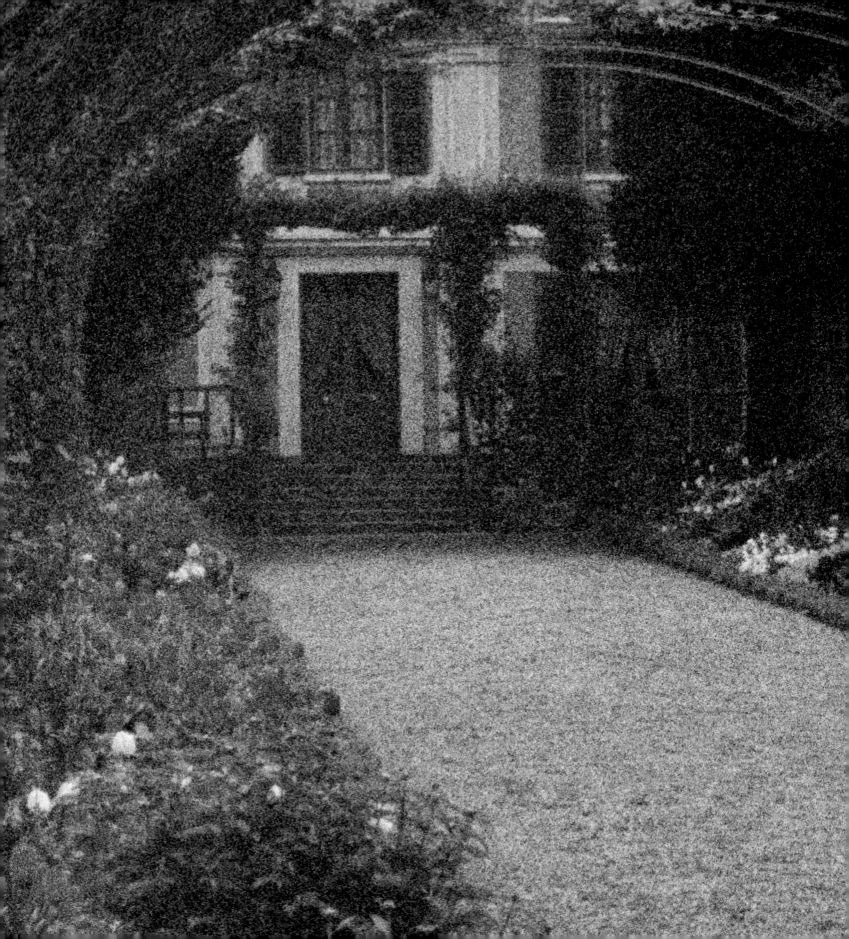

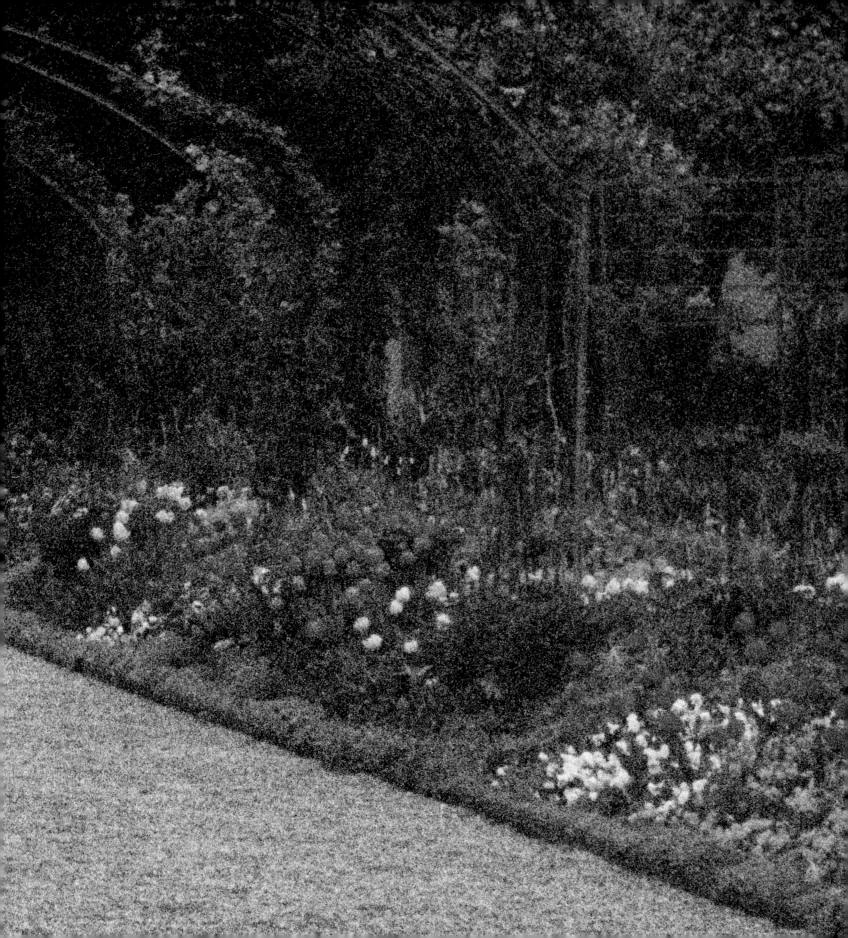

Garden benches,
September

Opposite:
The Clos Normand, May,
from Claude Monet's
bedroom window

Overleaf:
The Clos Normand,
October

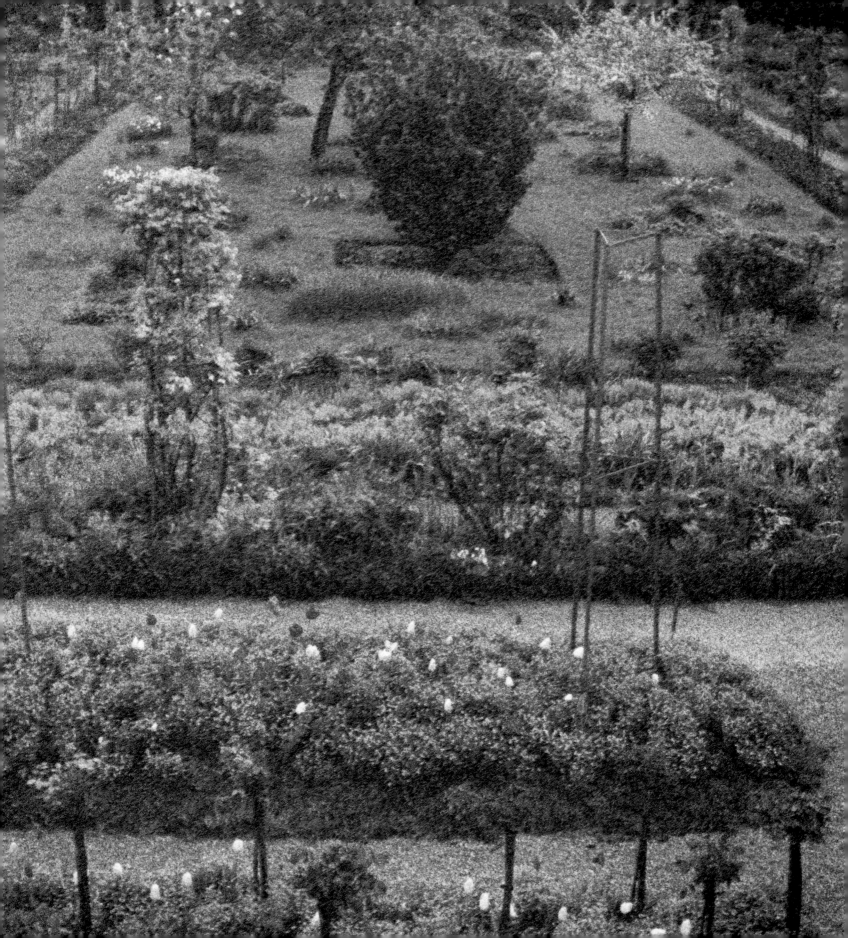

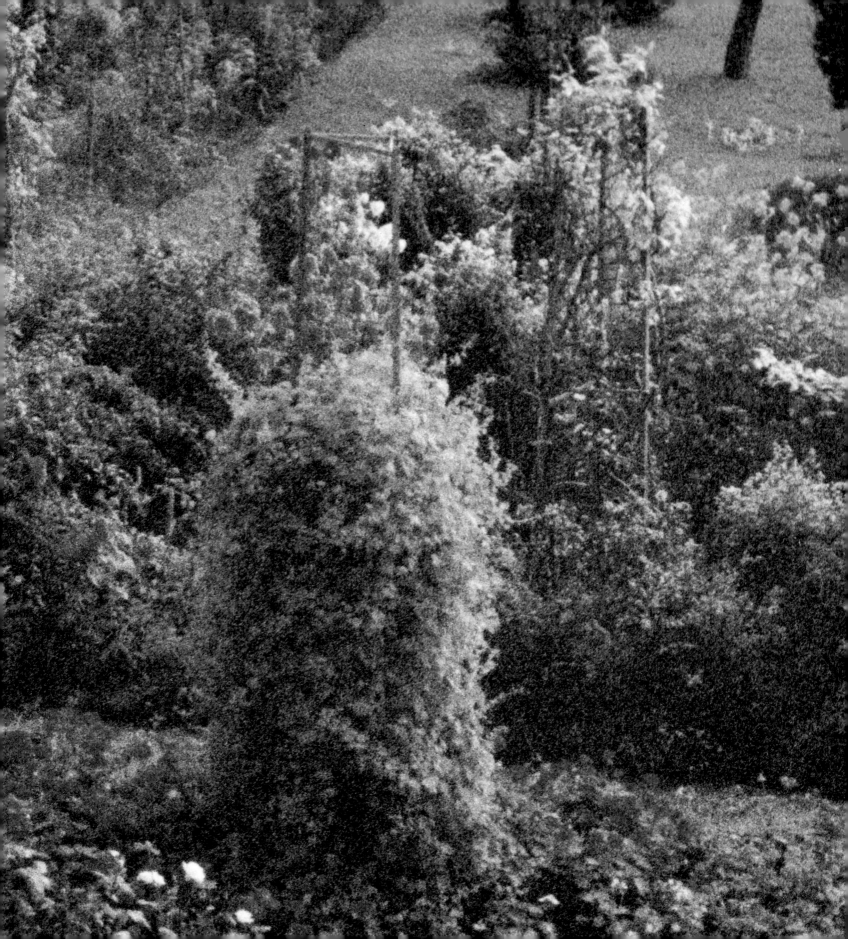

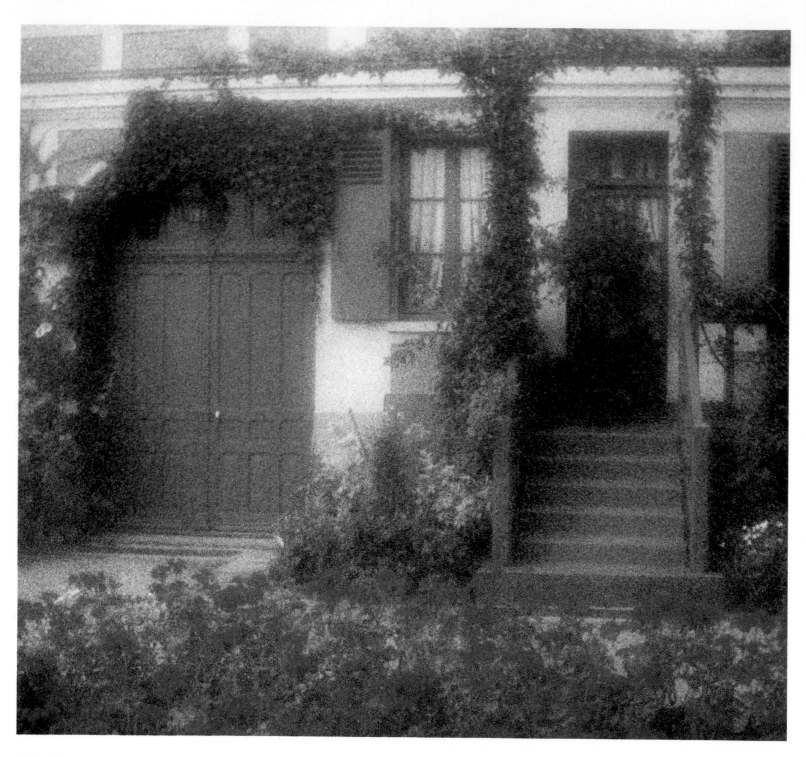

The kitchen door,
September

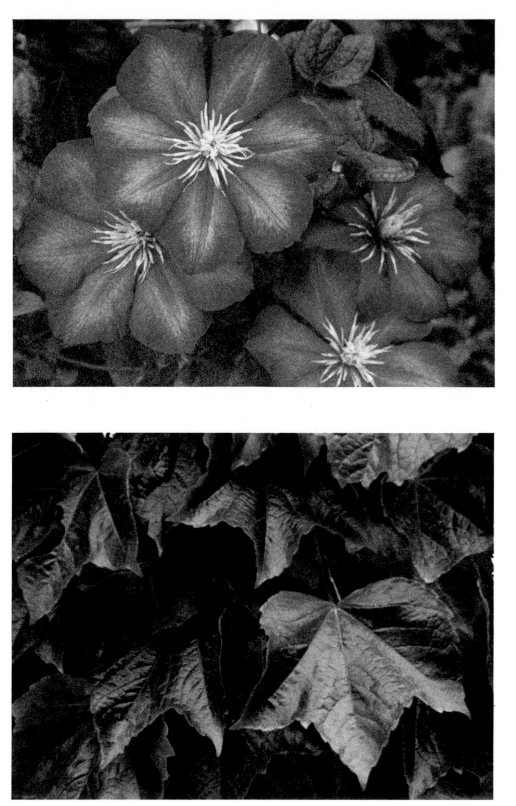

Clematis

Maple leaves

Overleaf, left and right:
The Clos Normand, May

29

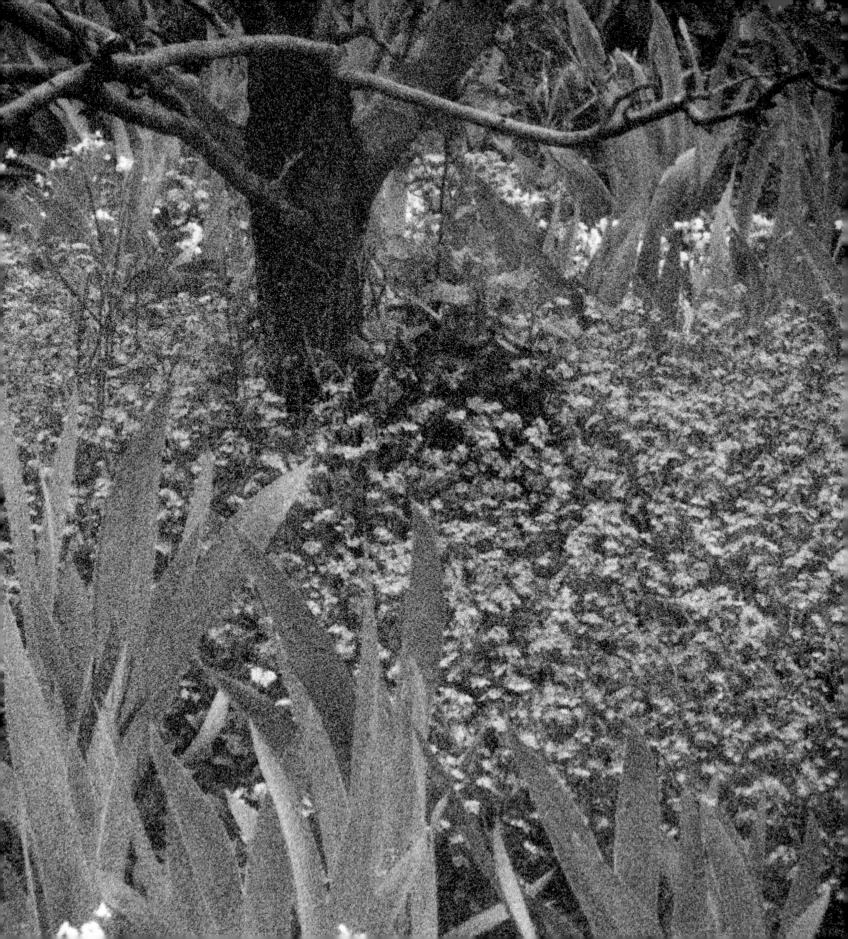

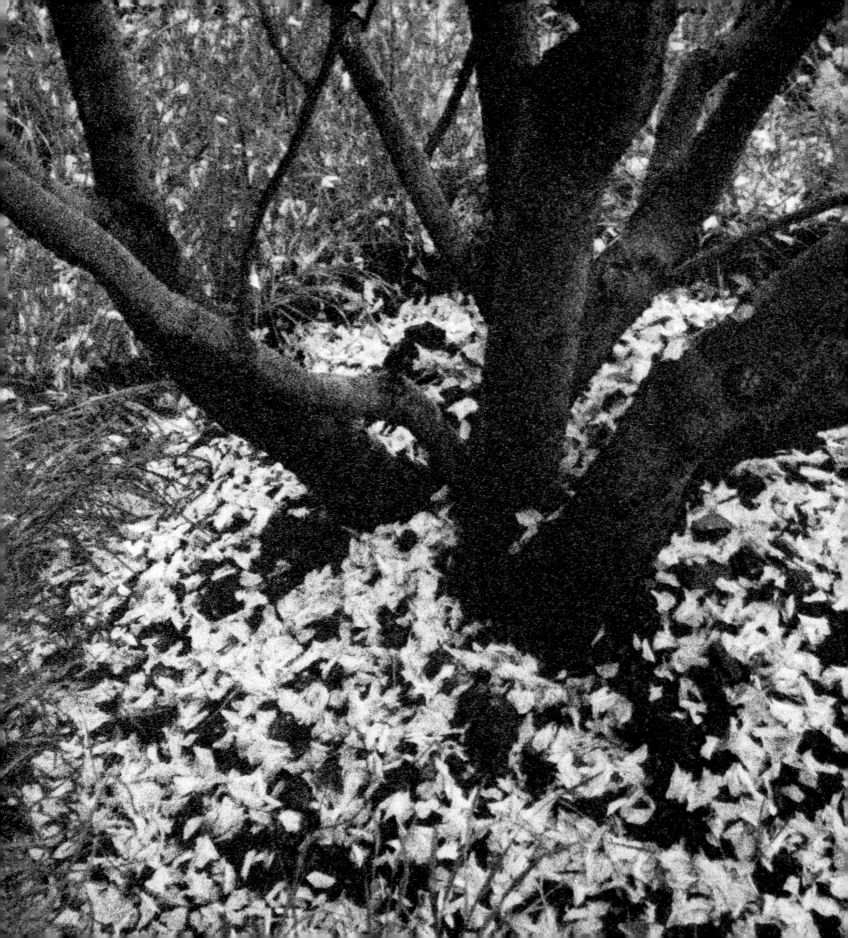

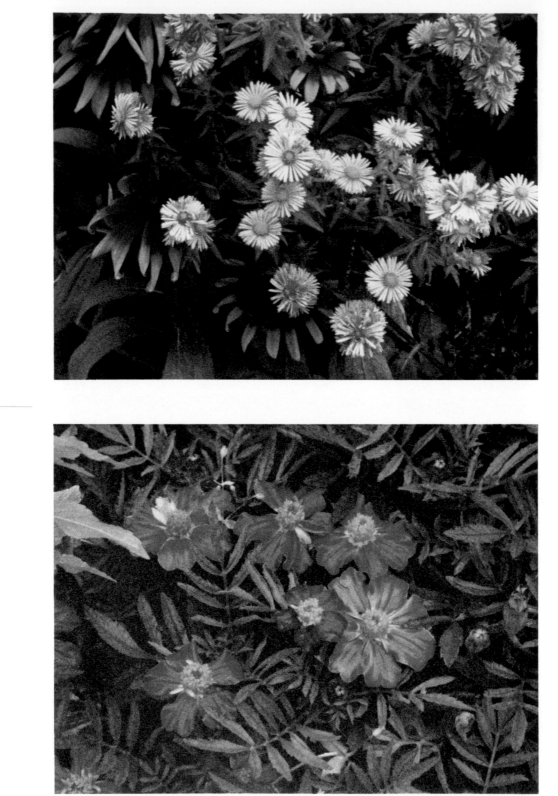

Asters

Marigolds

32

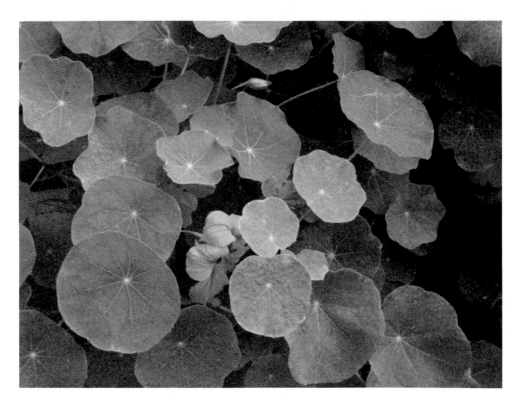

Nasturtium leaves

Black-eyed Susans

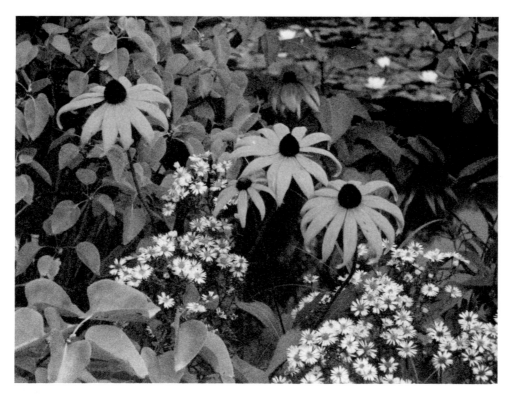

Overleaf:
*Azalea and Japanese
maple*

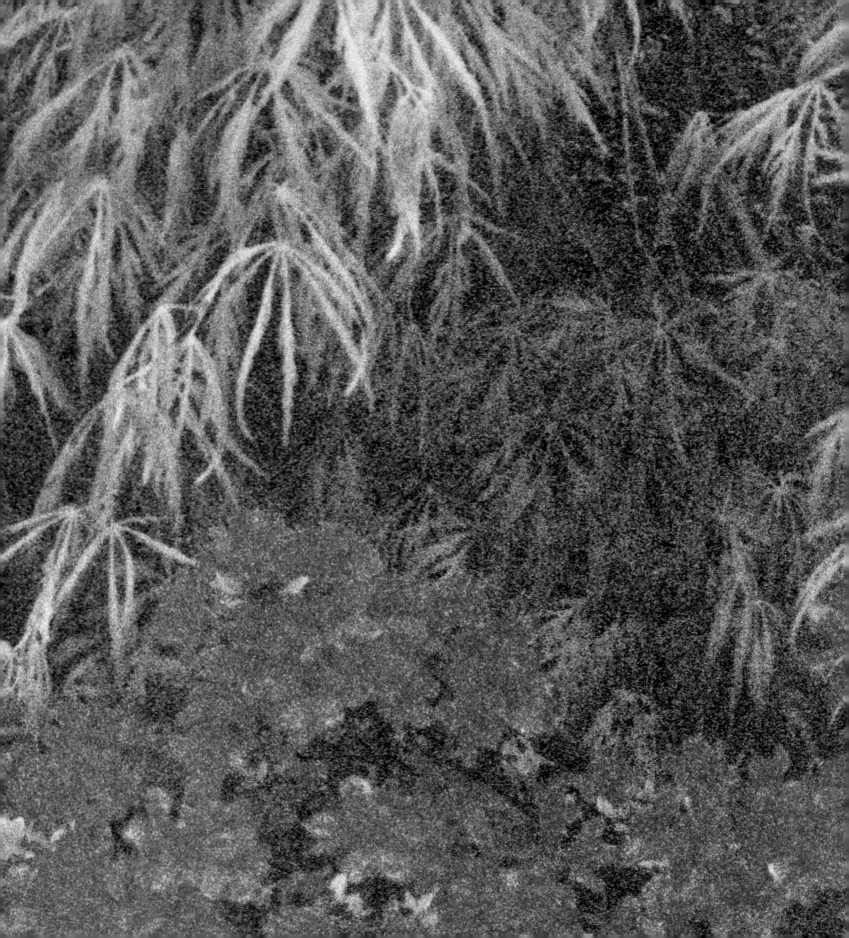

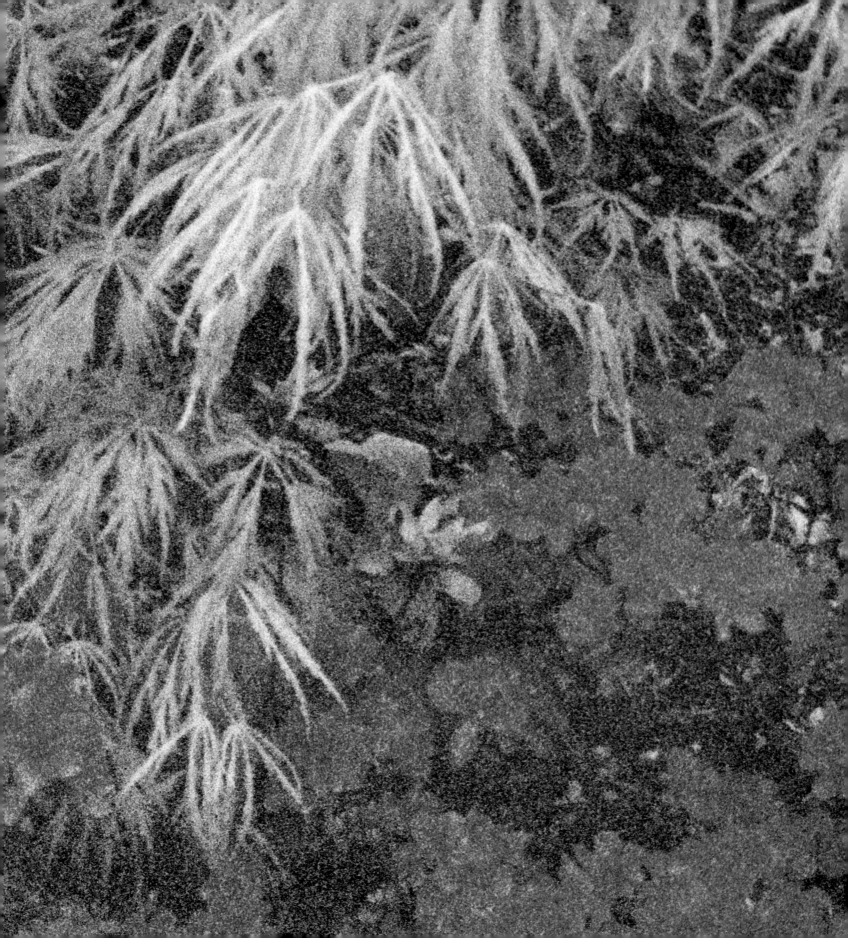

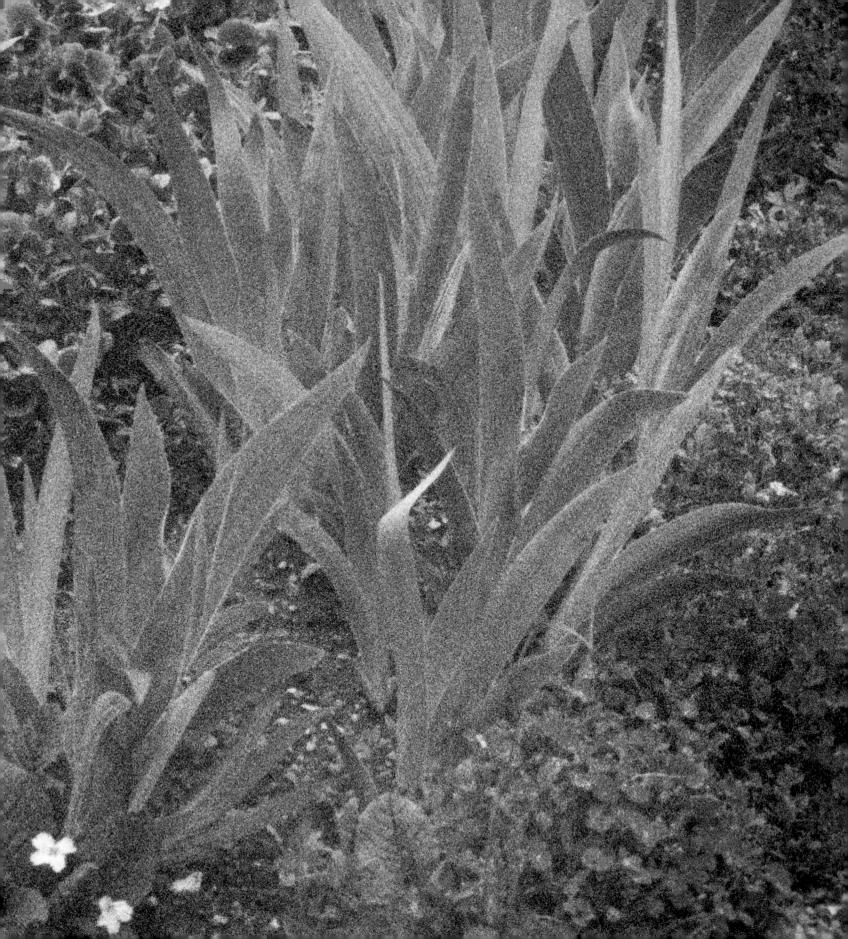

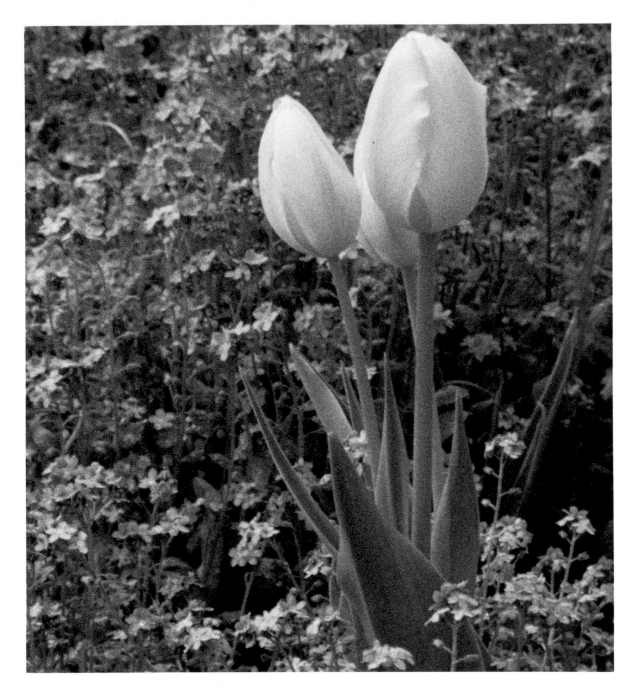

Tulips

Opposite:
Irises

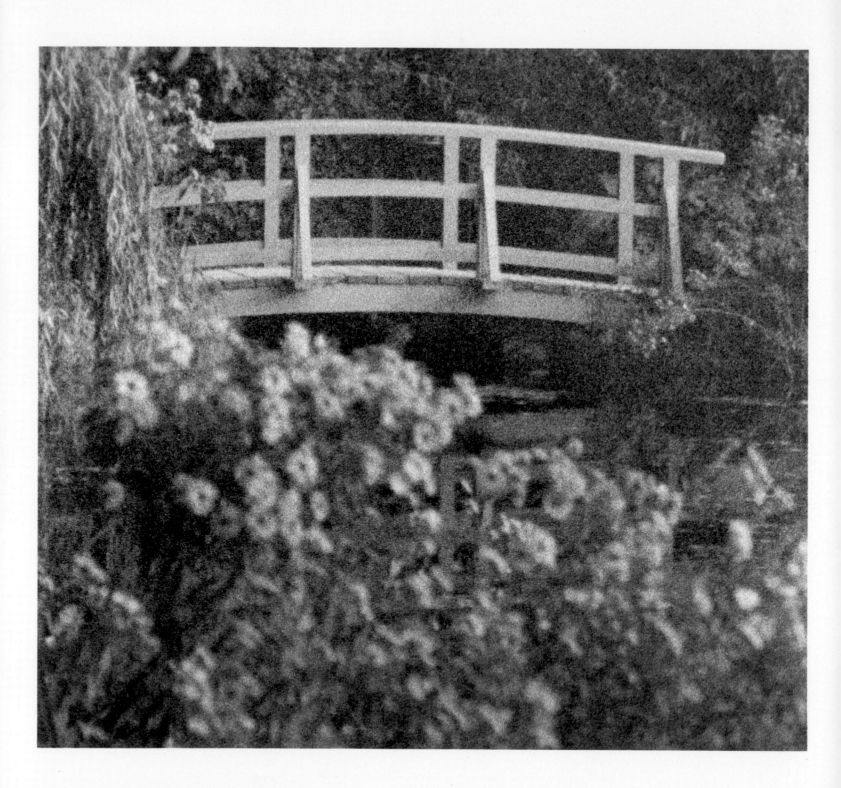

THE
WATER GARDEN

AT THE BOTTOM of the Clos Normand and across the road ran the railroad tracks for the train to Gasny. Monet, in 1893, purchased a small plot of land on the other side of these tracks. It contained a stream and a small pond. Monet obtained, after a struggle, the permission of the village to divert the stream and enlarge the pond to grow aquatic plants. He now had a vision of a different kind of garden.

The water garden was modeled on Japanese gardens, with their shifting perspectives across a small body of water. Monet built a footbridge whose design might have been copied directly from one of his Japanese woodcuts. Later, in 1901, Monet purchased more land, enlarged the lily pond, and added a trellis over the bridge that made a canopy of wisteria. The banks were edged with irises and planted with maples, weeping willows, Japanese cherries, laurels, azaleas, rhododendrons, and a stand of bamboo. Meanwhile, water lilies became his passion. From horticulturists around the world, the packages arrived at Giverny.

Monet began painting the lily pond in the late 1890s. The Japanese Footbridge series dates from these years. After the work enlarging the pond in 1901 was completed, Monet began to paint the lilies again, concentrating on the surface of the pond. The Water Lily paintings were the crowning achievements of his old age. These paintings provided the impetus for the construction of the two new studios. Monet began to think in terms of large-scale works in the late 1890s, and built his second studio to accomodate them around 1897. But he had to wait until 1916, when the third studio was completed, to begin work on the big, decorative Water Lily paintings destined for the Musée de l'Orangerie in Paris, a project that occupied him until the end of his life. Almost to his last day, Monet labored to capture in paint the water lilies floating upon the transparent surface of the water.

Opposite:
Footbridge, October

Overleaf:
*The water garden,
September*

Pages 42–43:
Cosmos

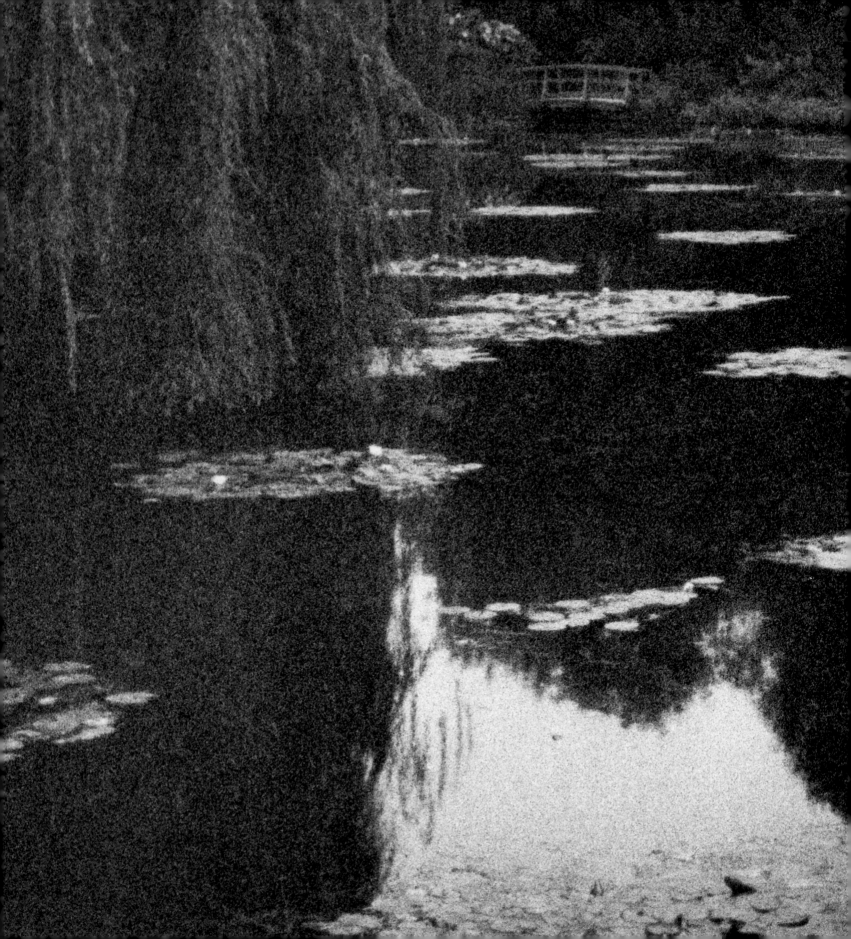

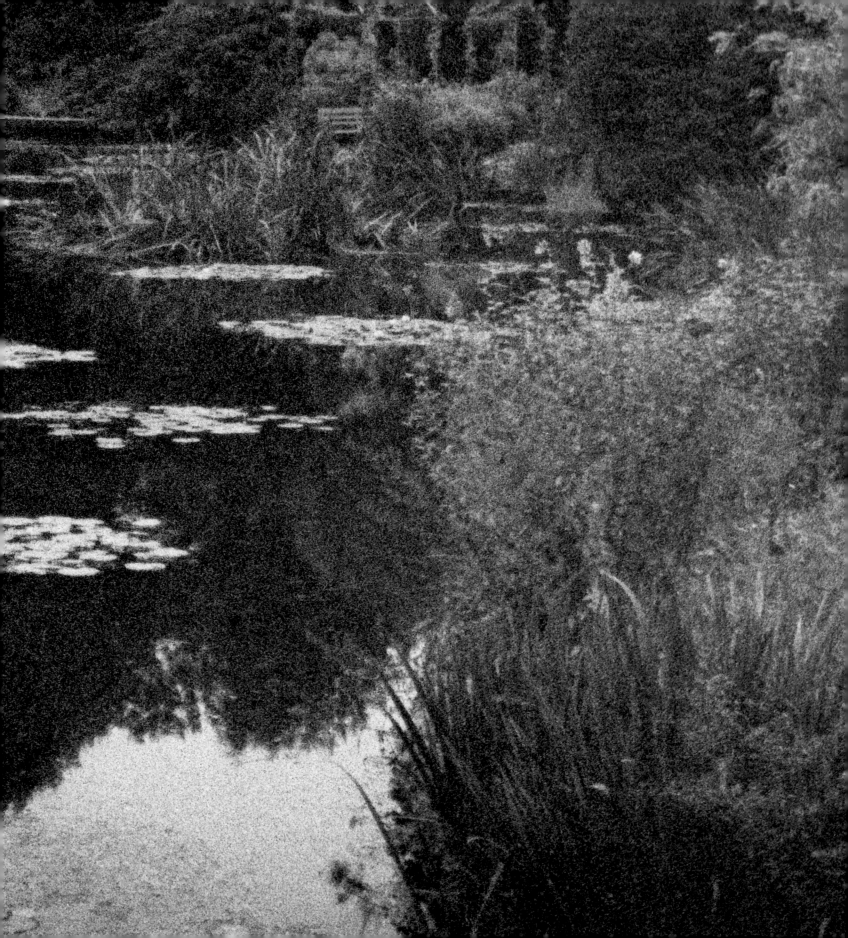

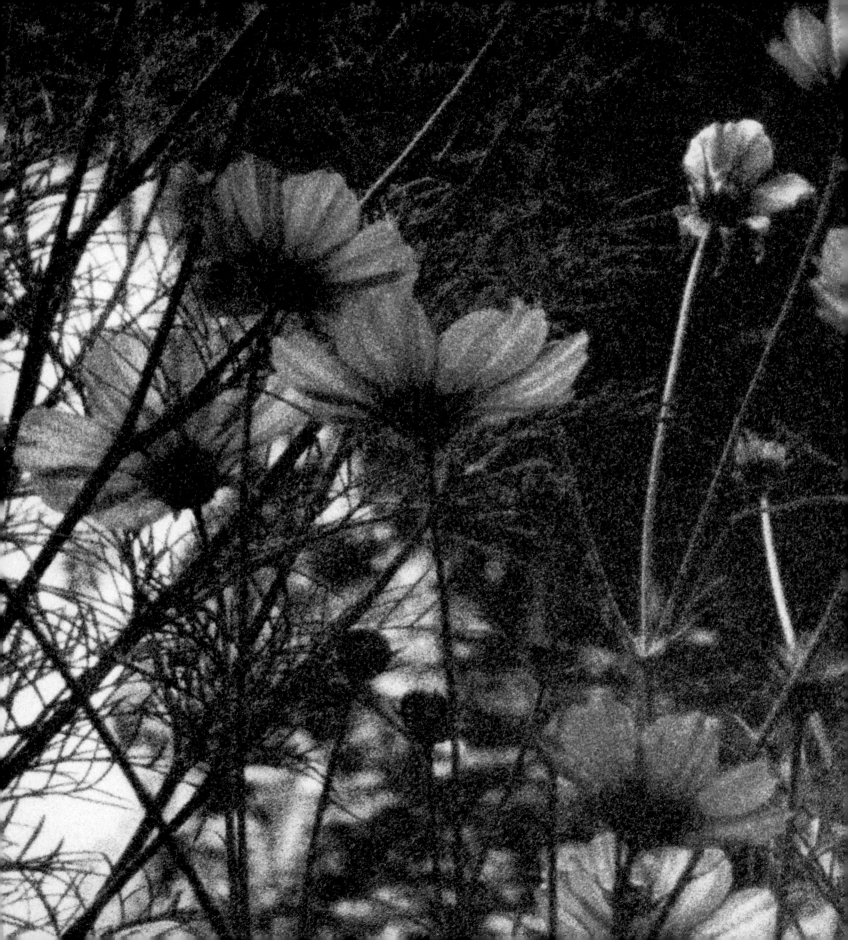

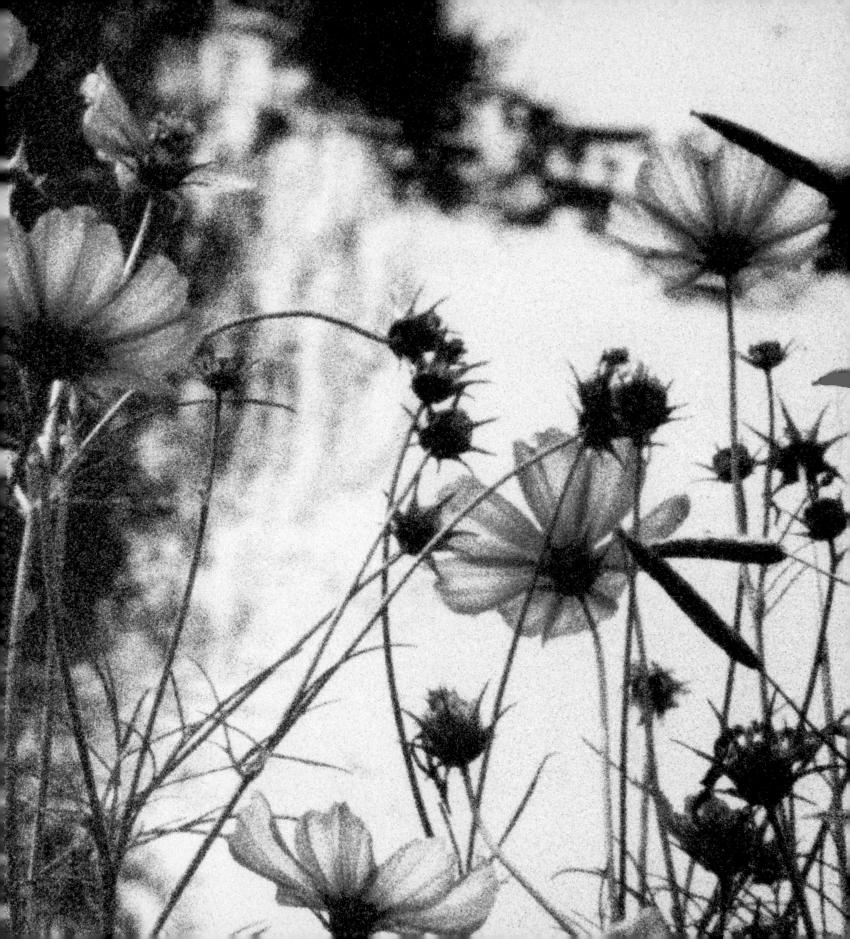

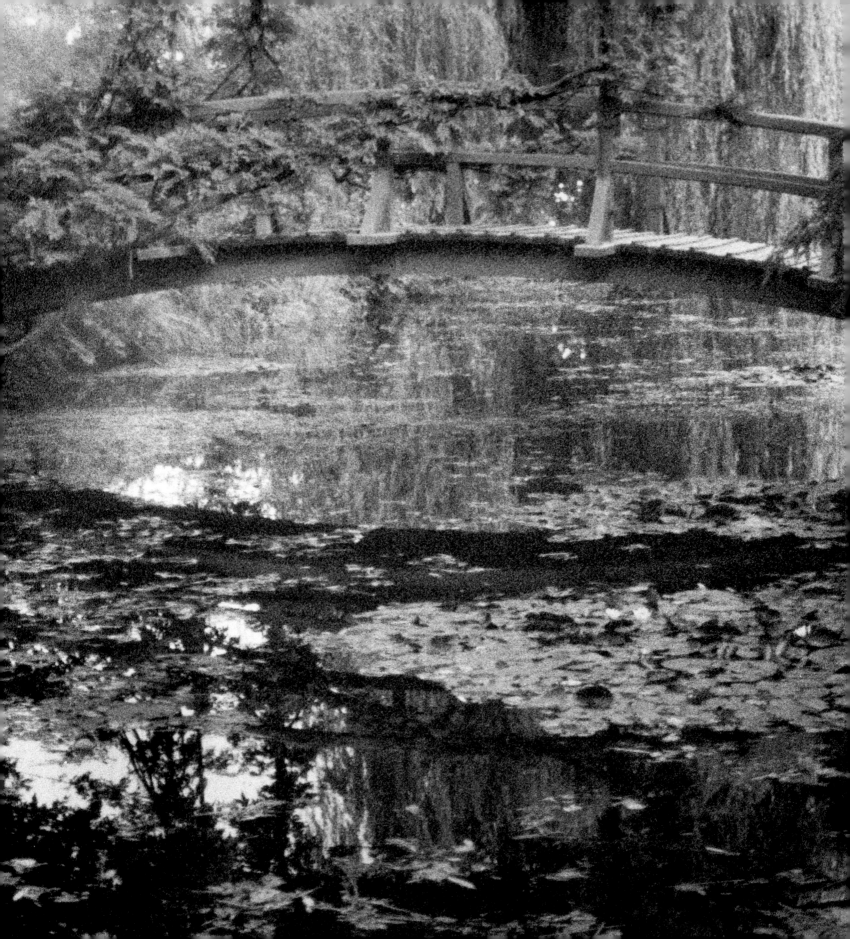

The Japanese Bridge,
May

Opposite:
The Japanese Bridge,
October

Overleaf:
The Japanese Bridge,
October

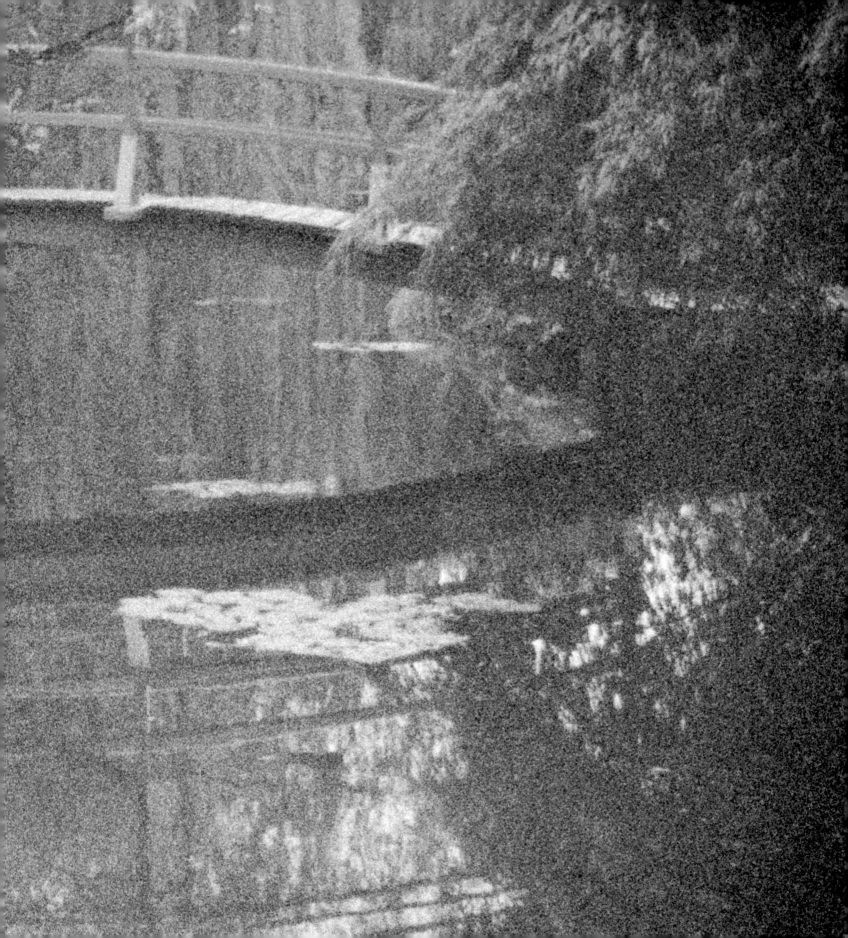

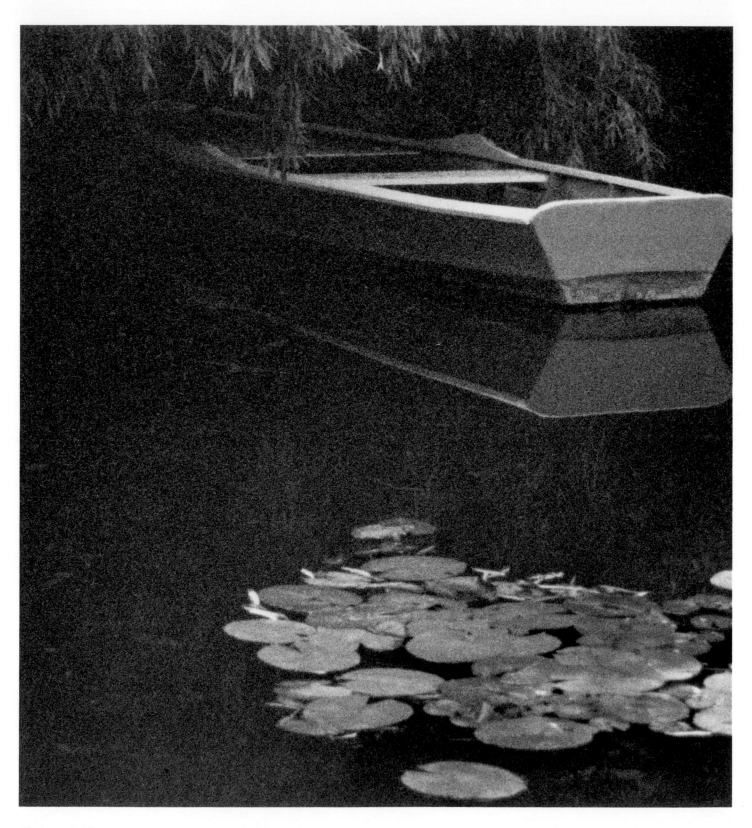

The boat, October

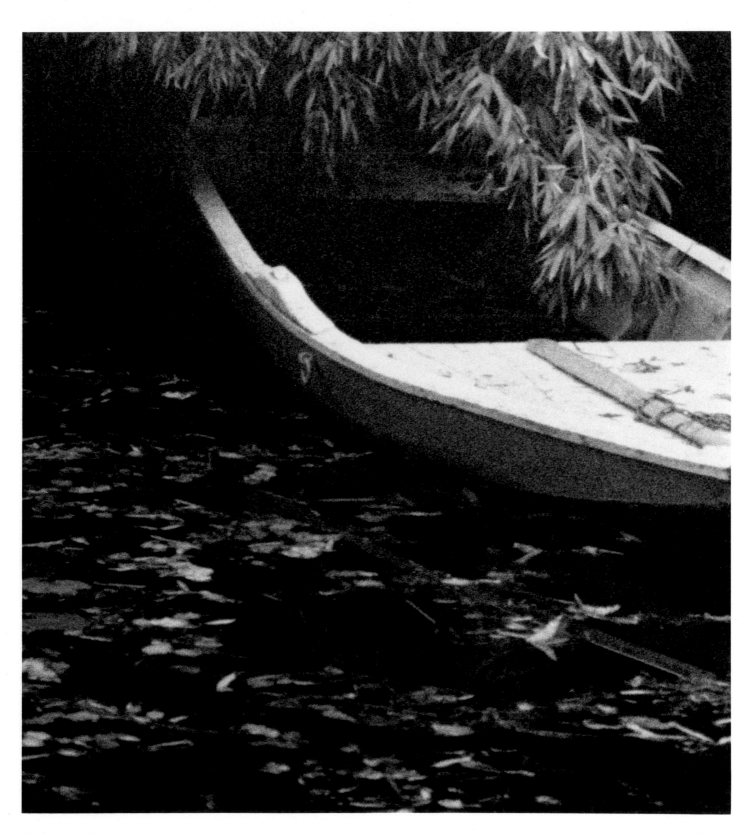

The boat, October

Overleaf:
The boat, May

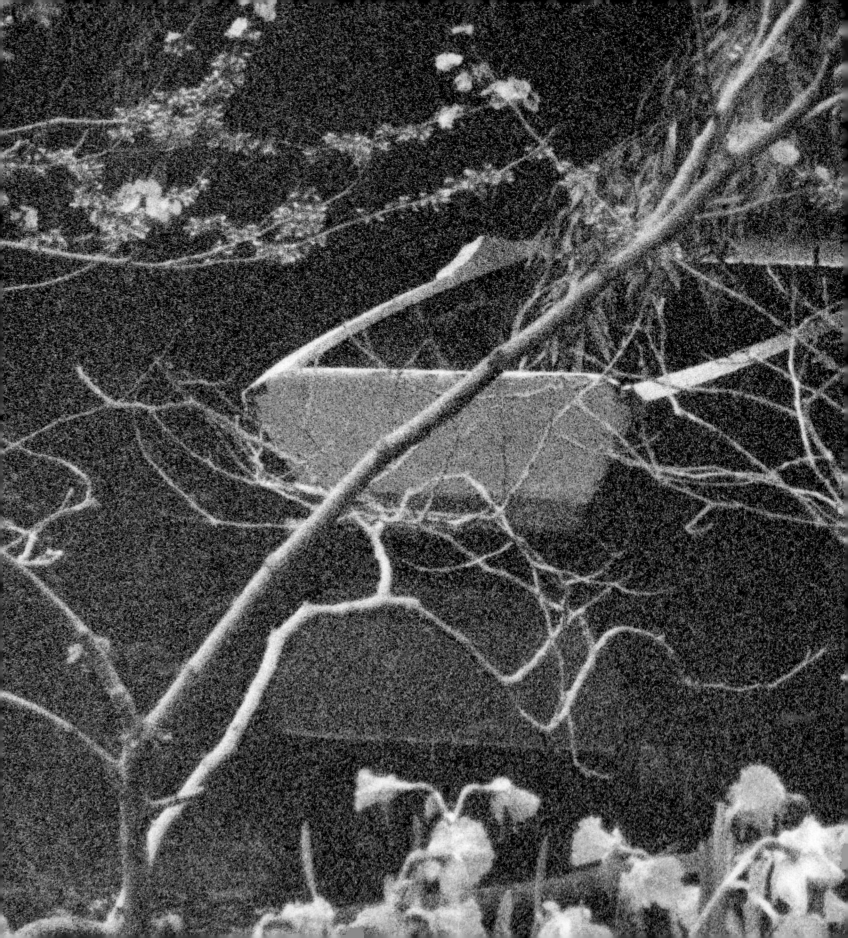

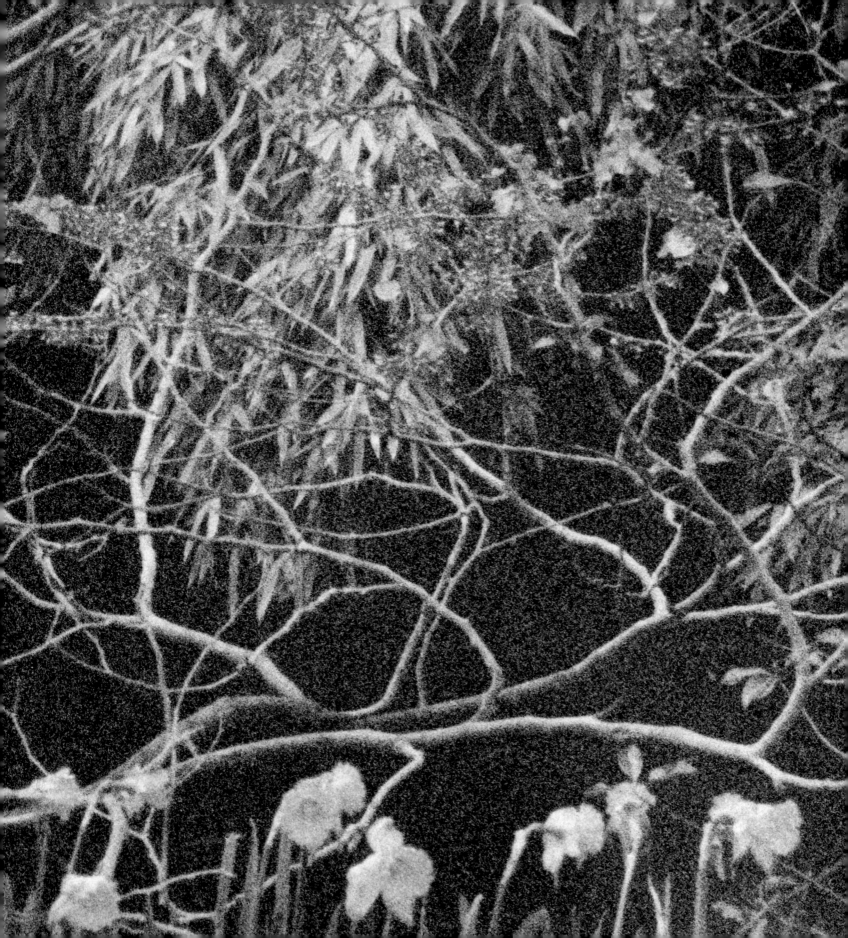

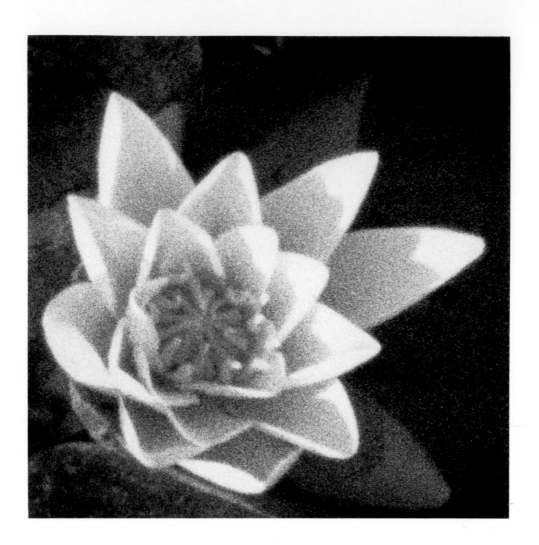

Water lily

Opposite and following pages:
Water lilies, October

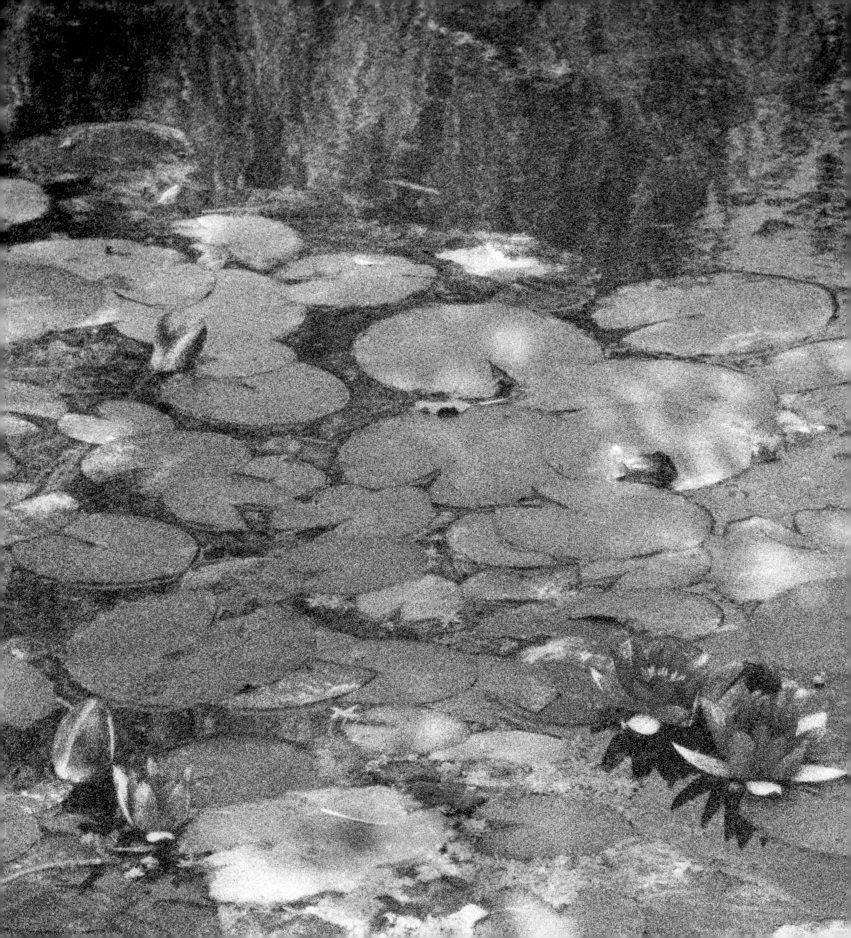

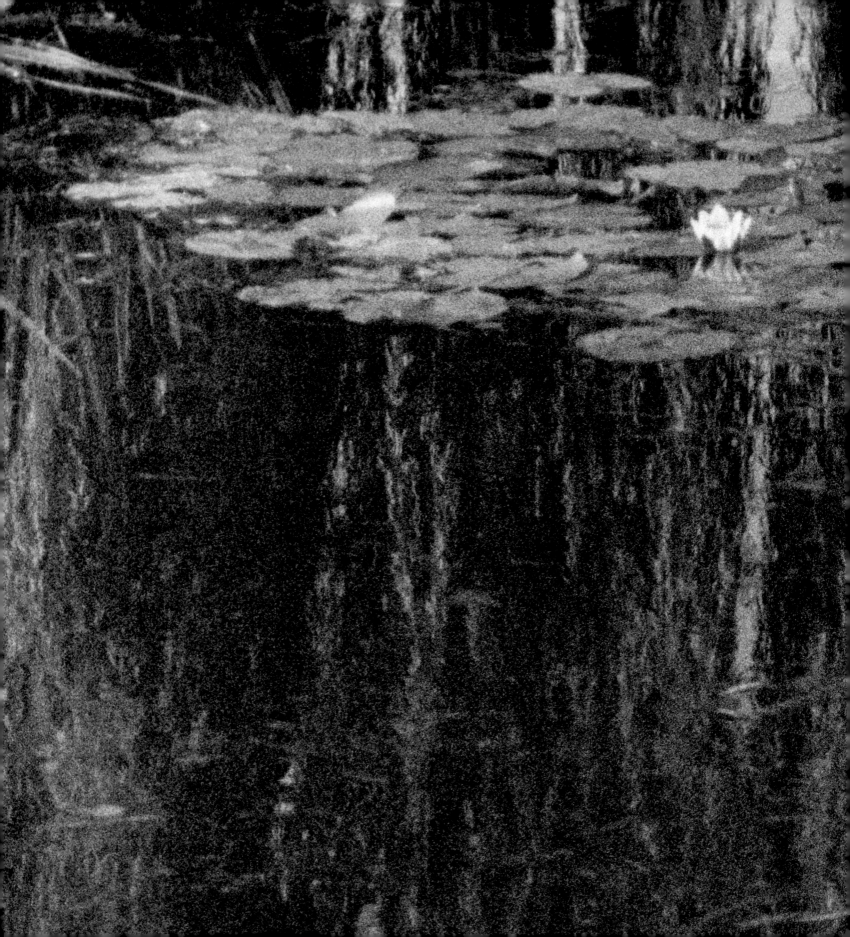

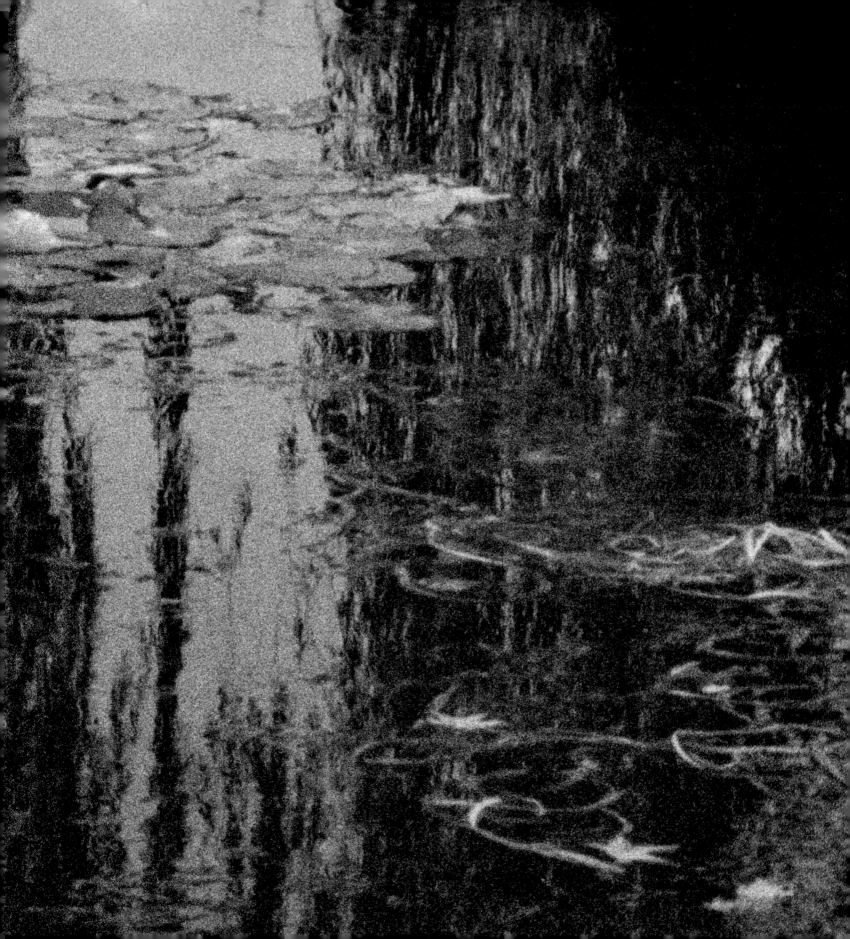

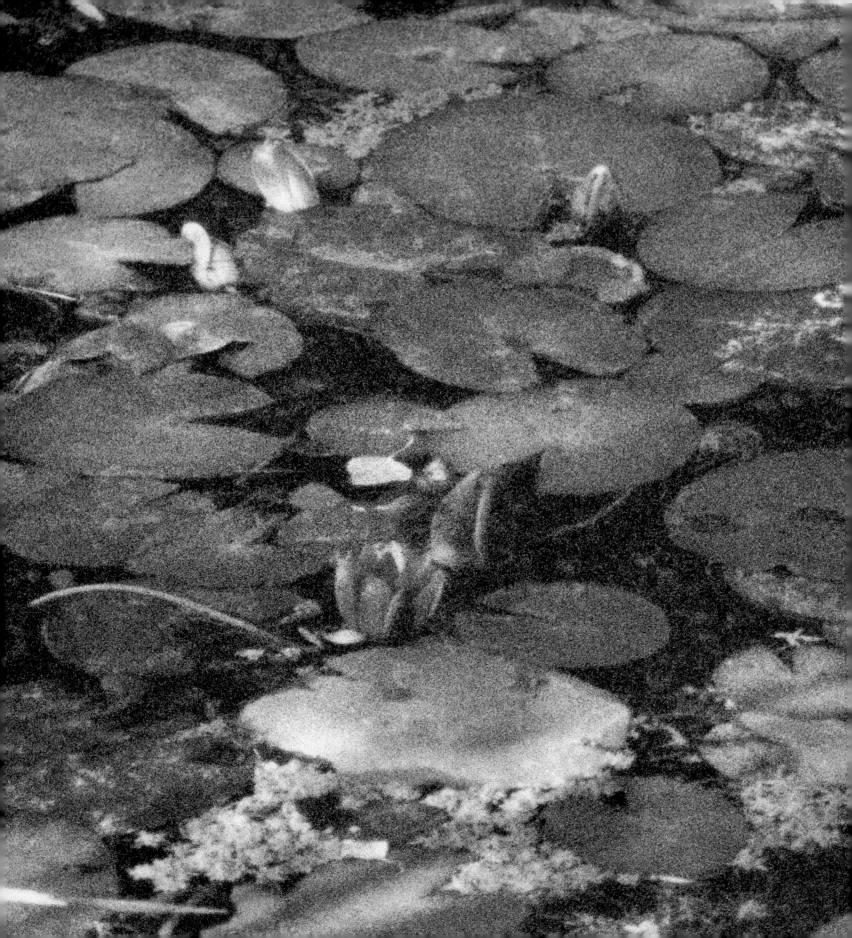

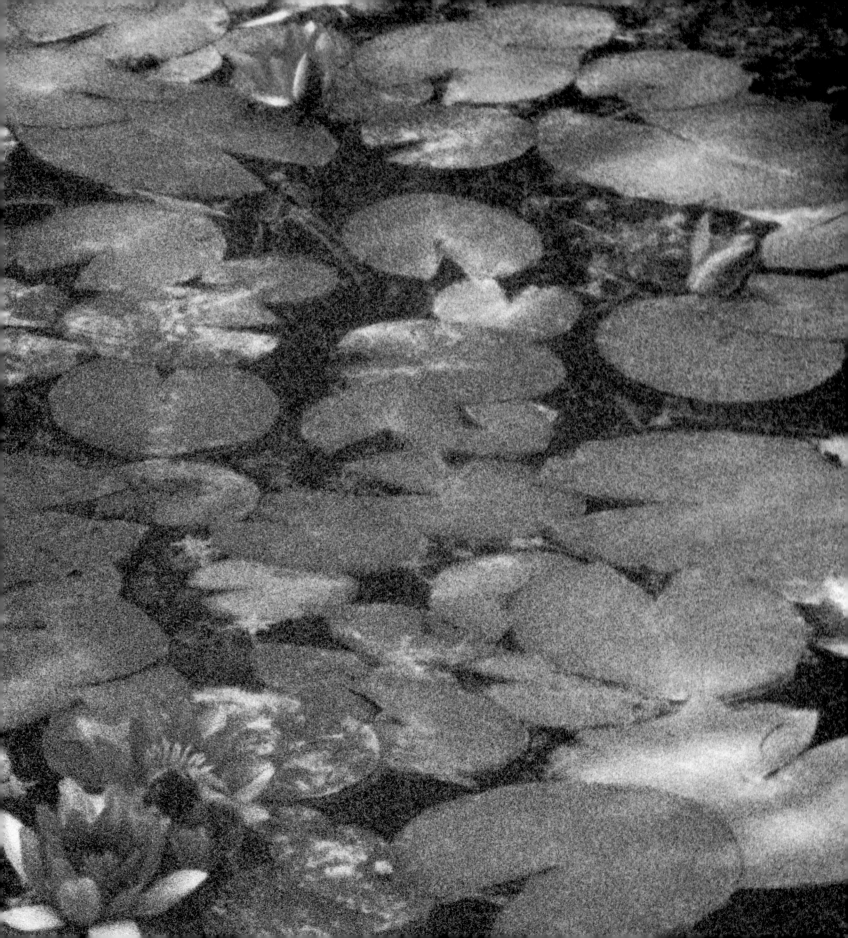

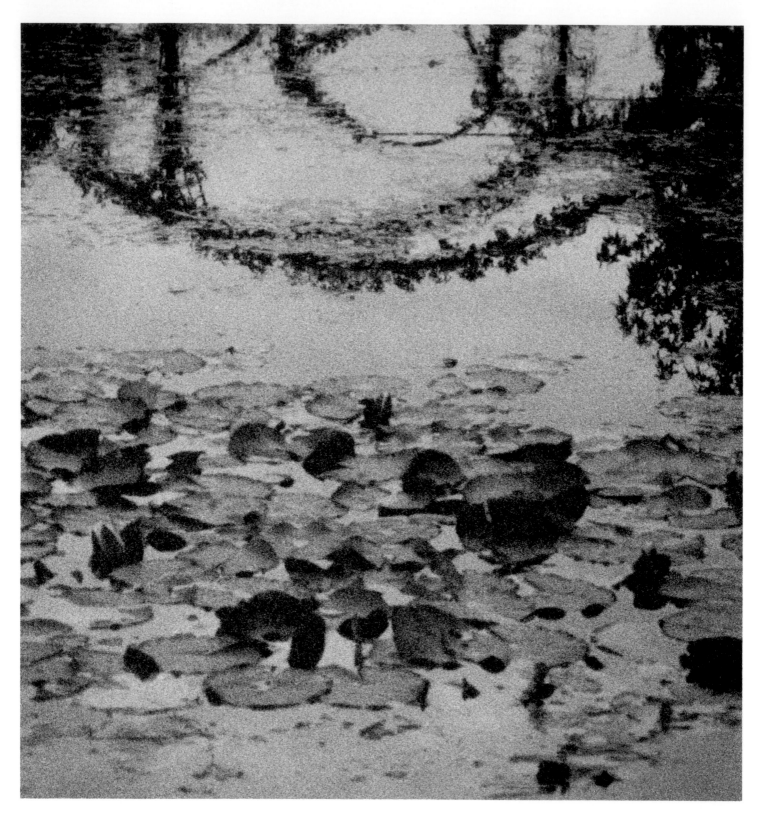

Water lilies, October

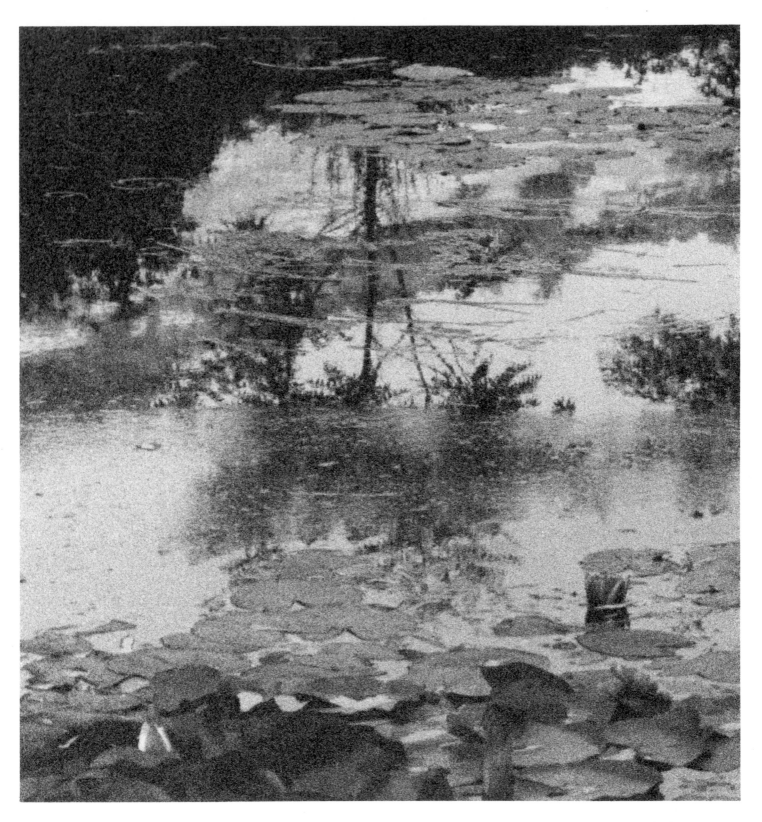

Water lilies, October

Overleaf:
Water lilies, September

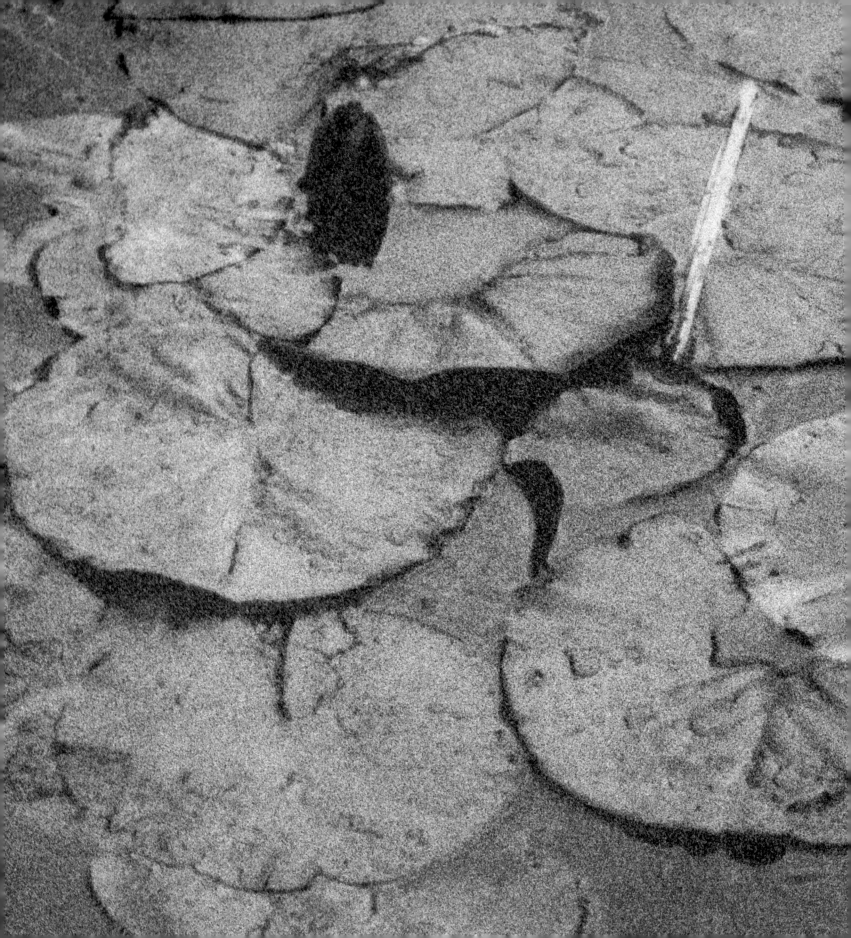

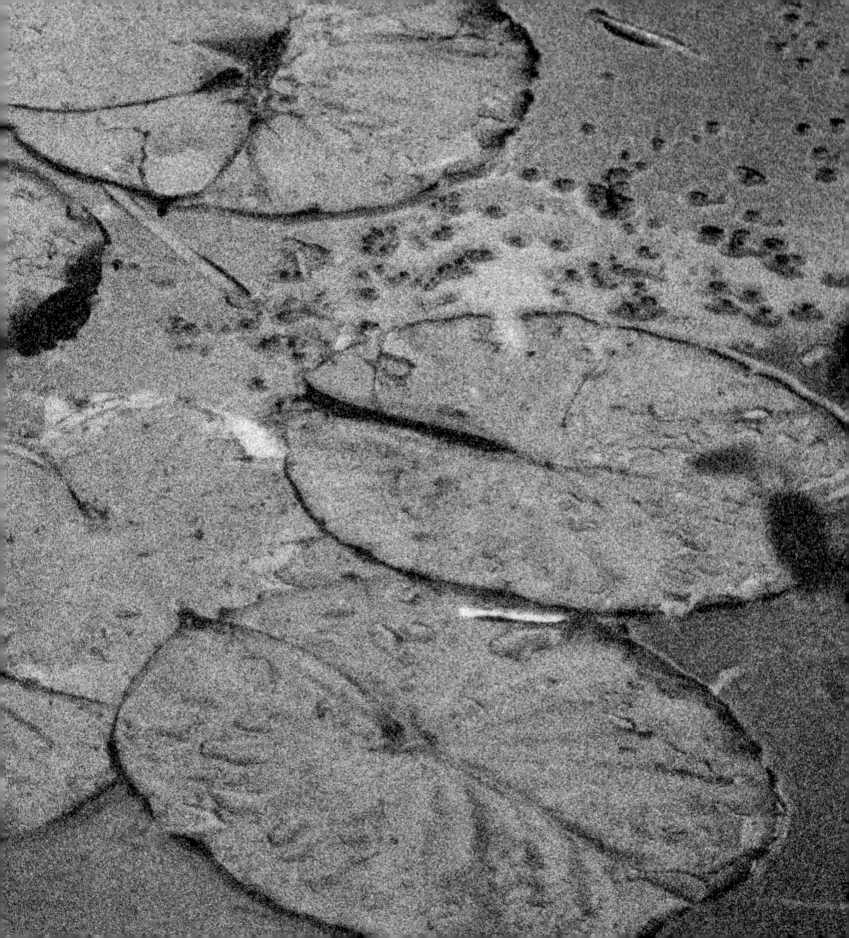

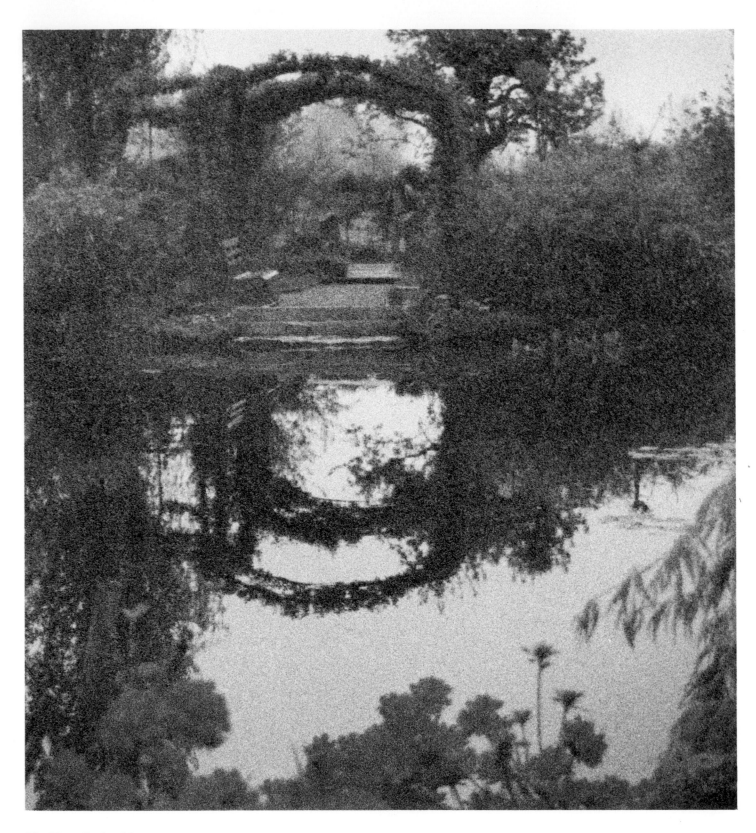

The Water Garden, May

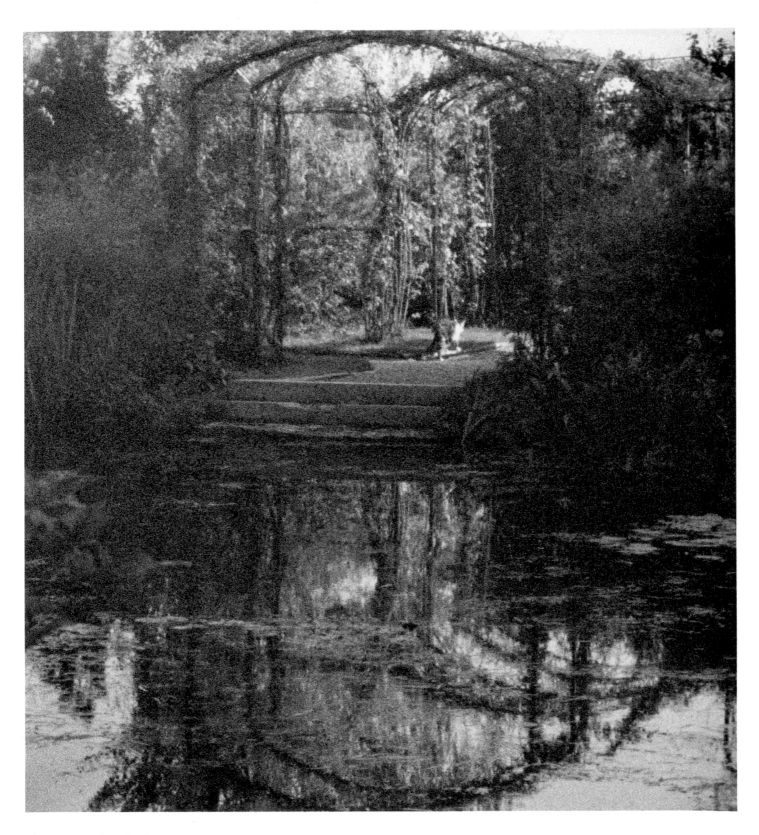

The Water Garden, October

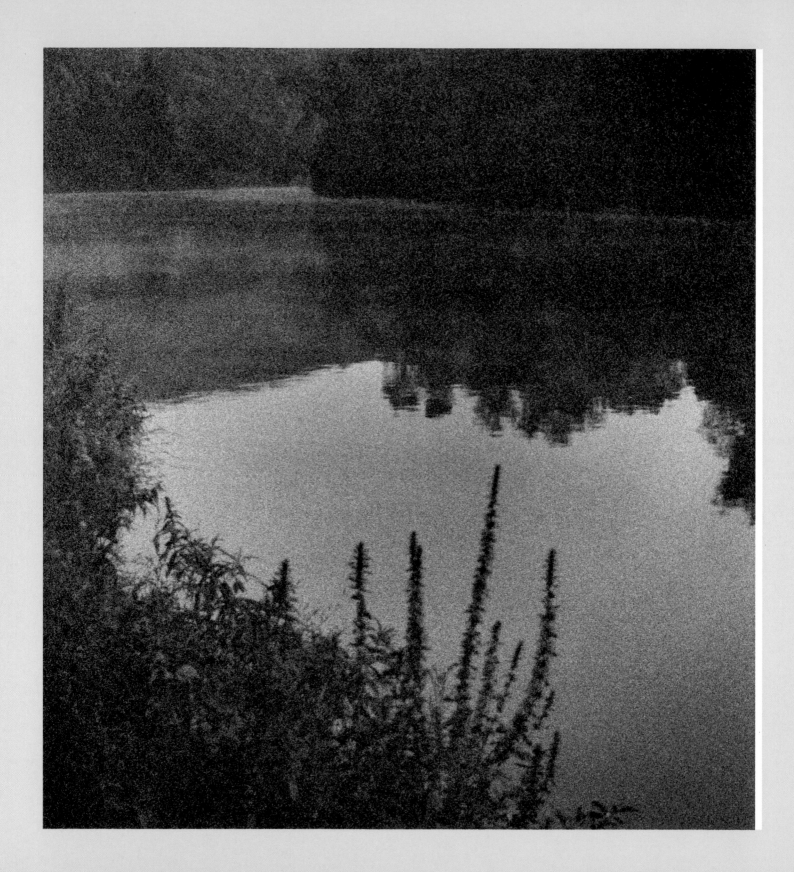

ENVIRONS

"I HAVE PAINTED the Seine all my life, at all hours of the day and in every season," Monet once said. Giverny was less than a mile from the Seine, and as soon as he moved there, he began to explore. He kept a boat, "the floating studio," on the small Ile aux Orties not far from the house, and in this he travelled the river. It was just south of the boathouse that Monet painted his Mornings on the Seine series in the late 1890s.

It was also in the vicinity of Giverny that Monet painted his Haystacks and Poplars earlier in the decade. The poplars were in Limetz, not far from Giverny, and the town put them up for sale before the series was completed. Monet agreed to pay a wood dealer the difference between the highest bid he was willing to make and the auction price for the trees if he in turn would not cut them down for several months.

The valley of the Seine has developed, in the late twentieth century, into a giant industrial complex. Vernon, where Monet sent his children to school, is now the major market town of eastern Normandy. Many of the new subway cars traveling under the streets of New York are made in Vernon. But in spite of the development along the river, tiny villages and small farms still cling to its banks. These quiet backwaters and bucolic stretches still look as they did when Monet went out painting in his floating studio.

Opposite:
The Seine, October

Overleaf:
Poplars, road near Gasny

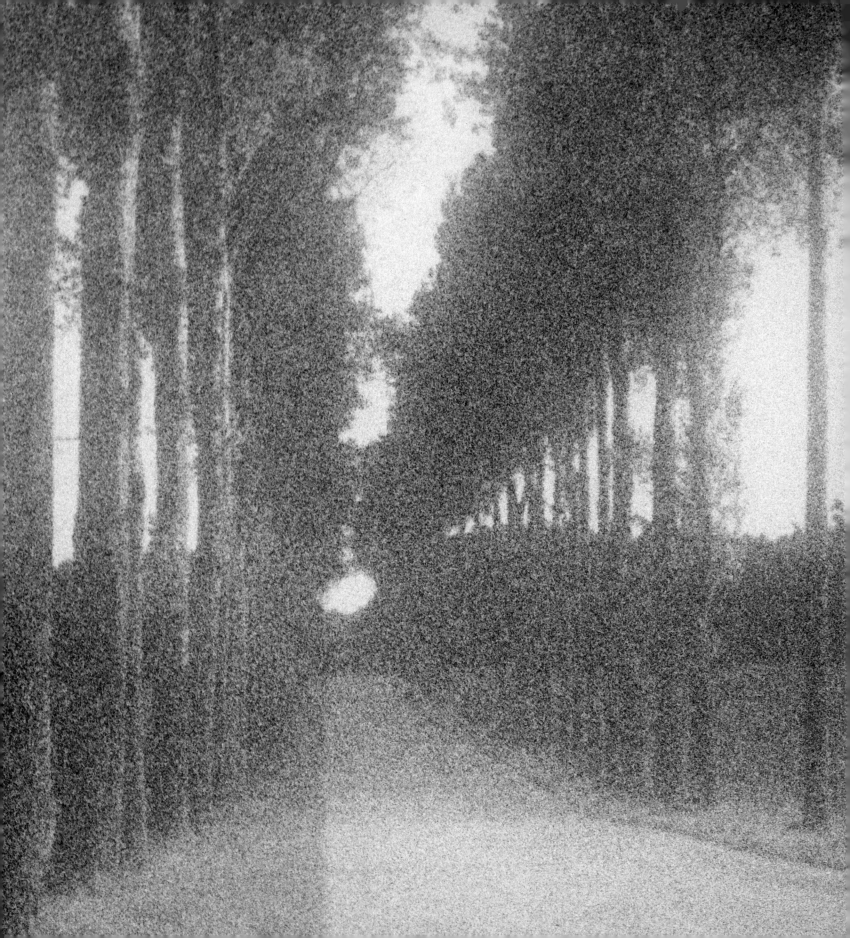

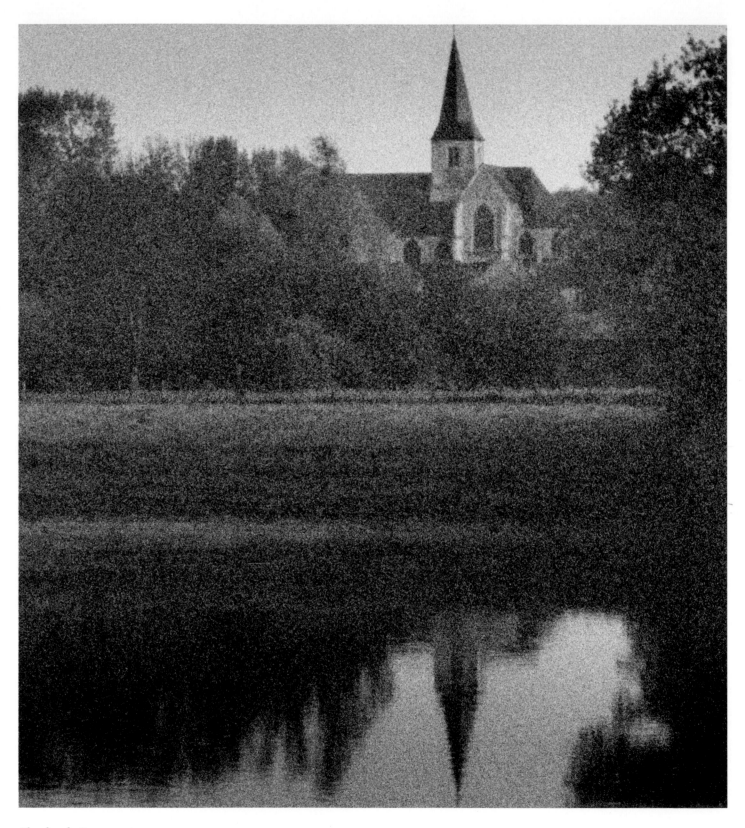

The church, Bennecourt

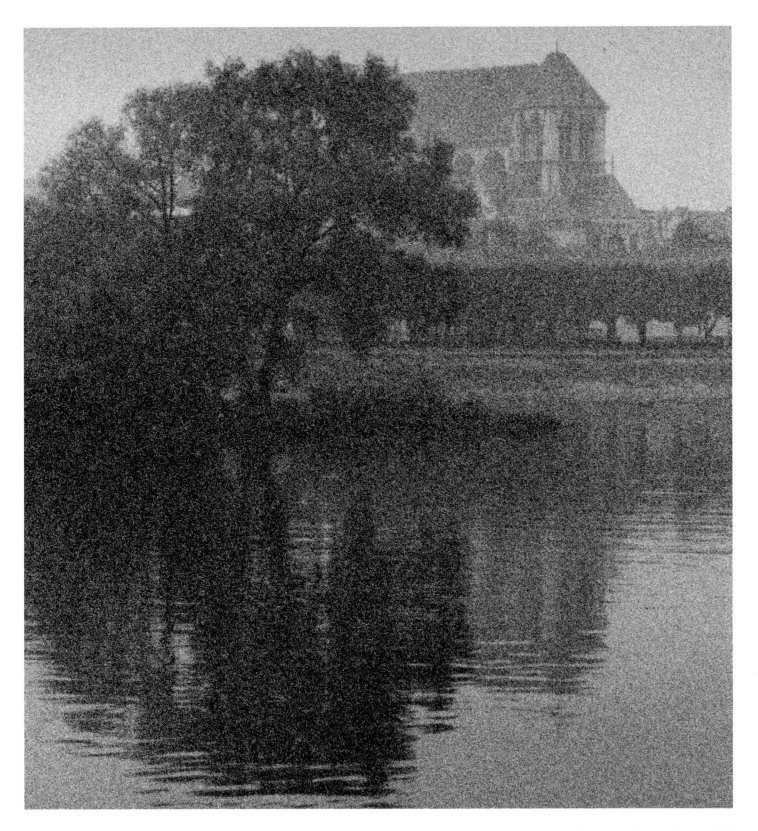

The church, Vernon

Overleaf: *Ruined house, Le Grand Val*

Pages 72–73: *The Seine, October*

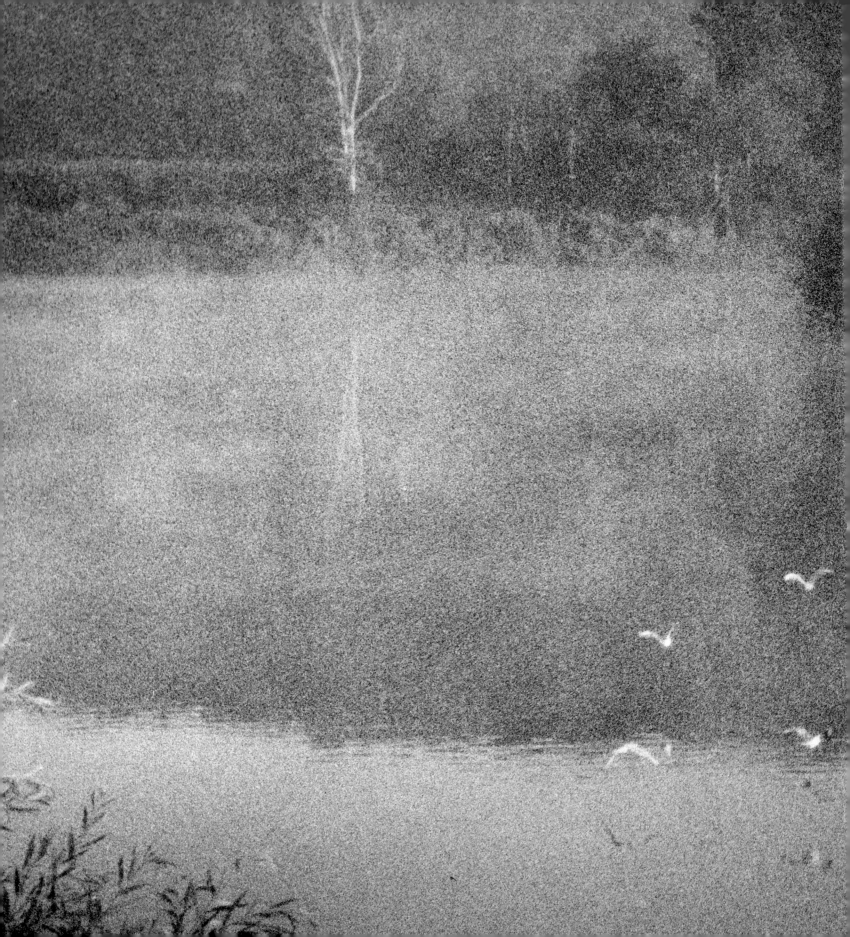

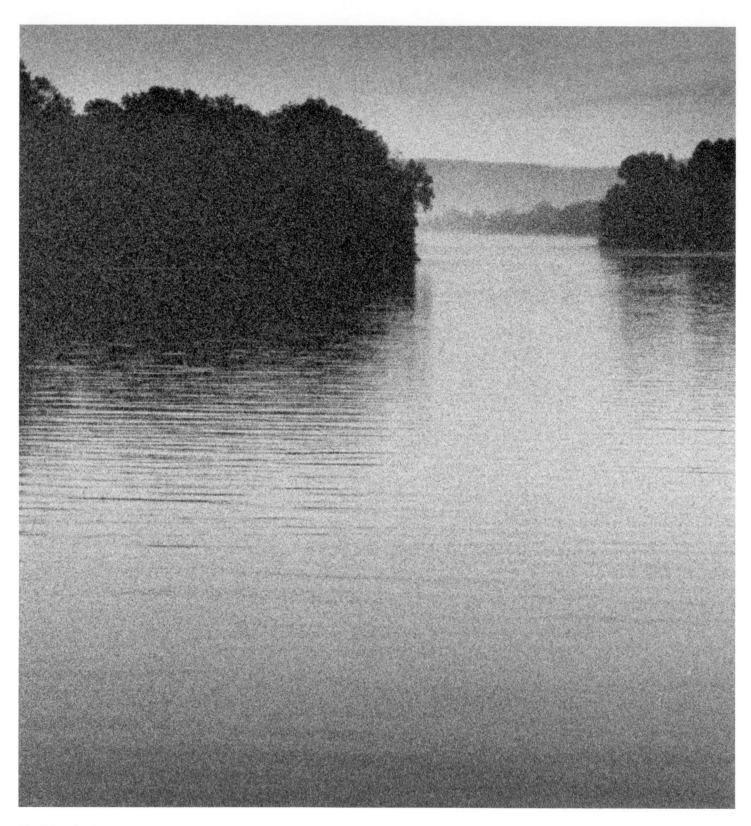

The Seine, October

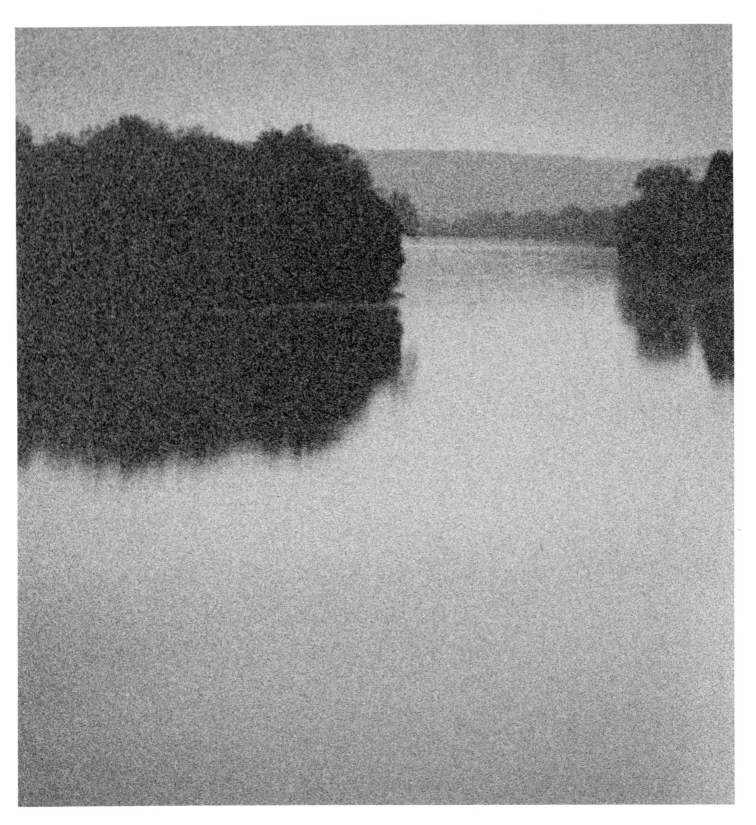

The Seine, May

Overleaf, left: *The Seine, October*

Overleaf, right: *Field of maize near Jeufosse, October*

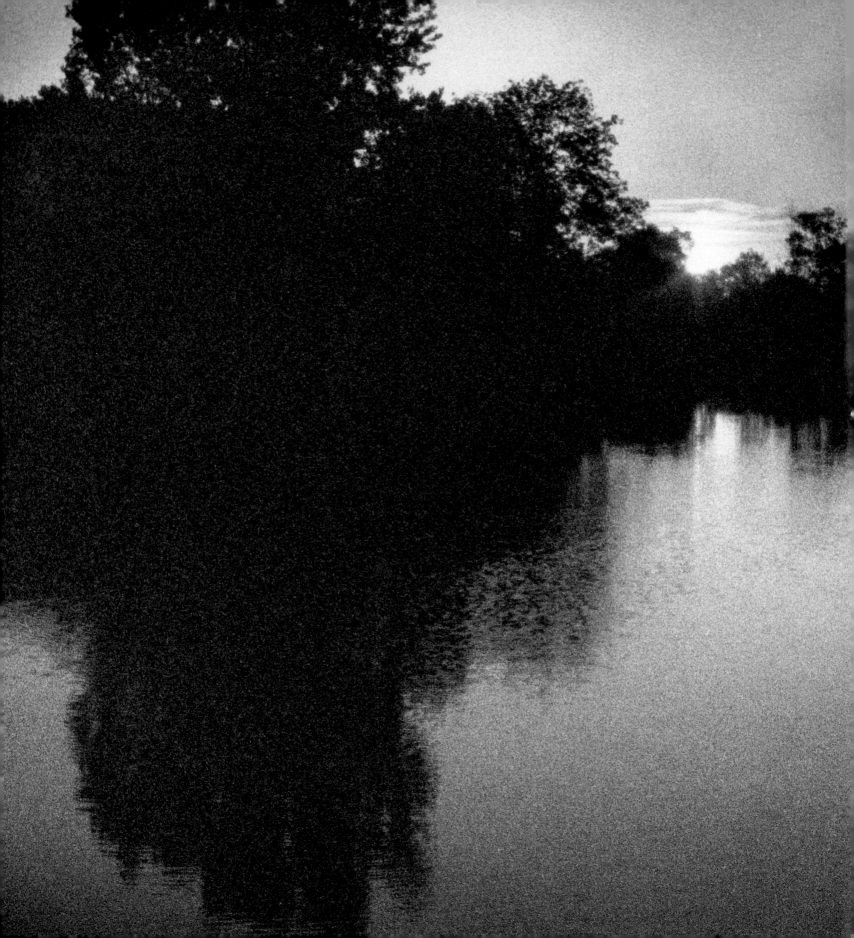

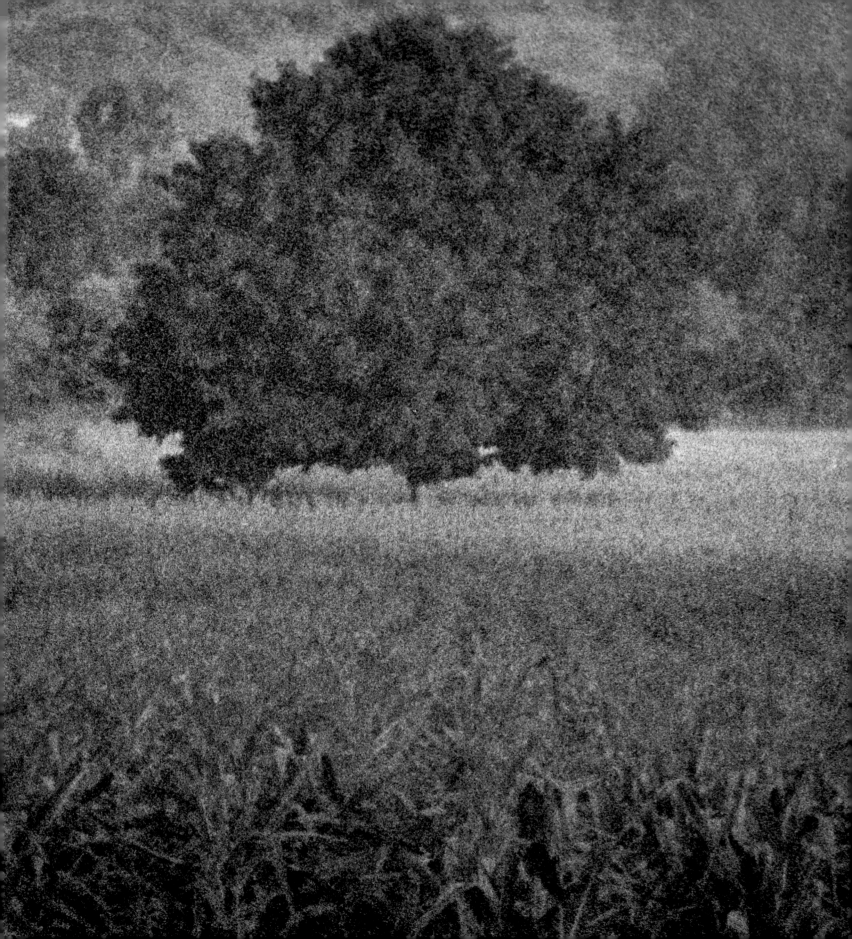

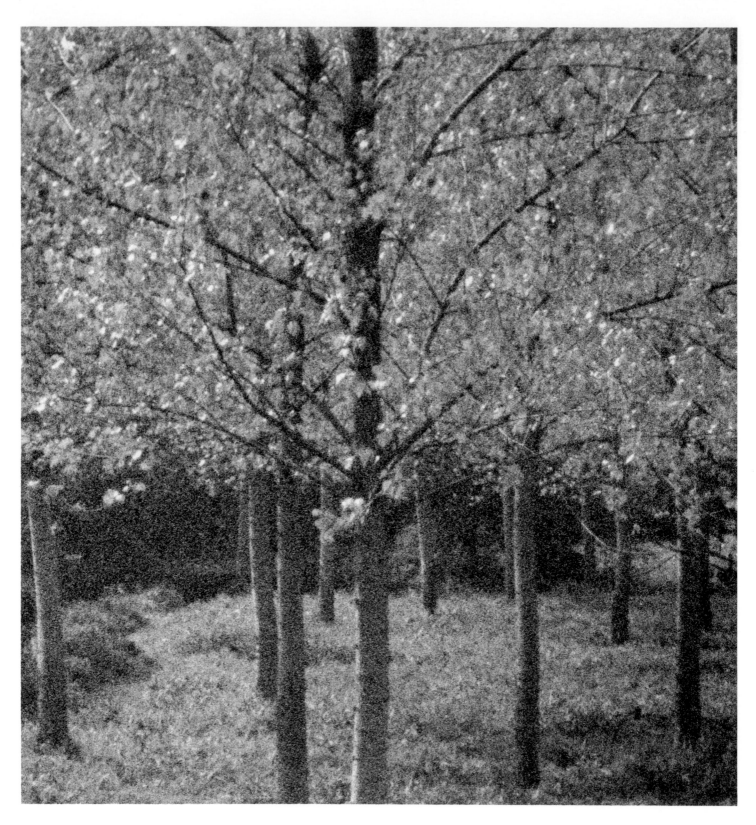

Grove near Limetz, May

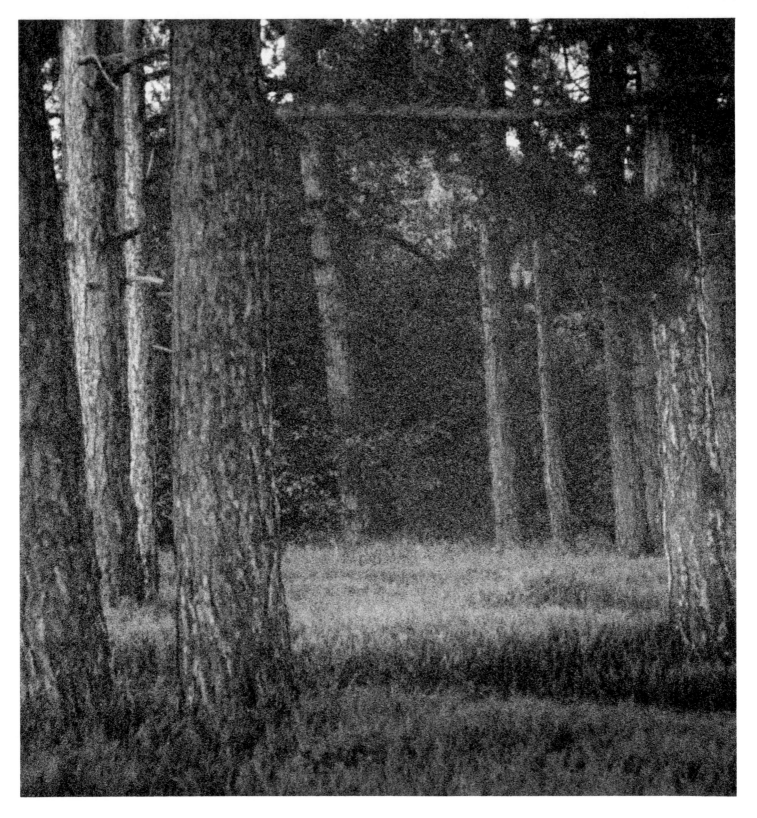

Grove near Villez, May

Overleaf:
Woods near Giverny, October

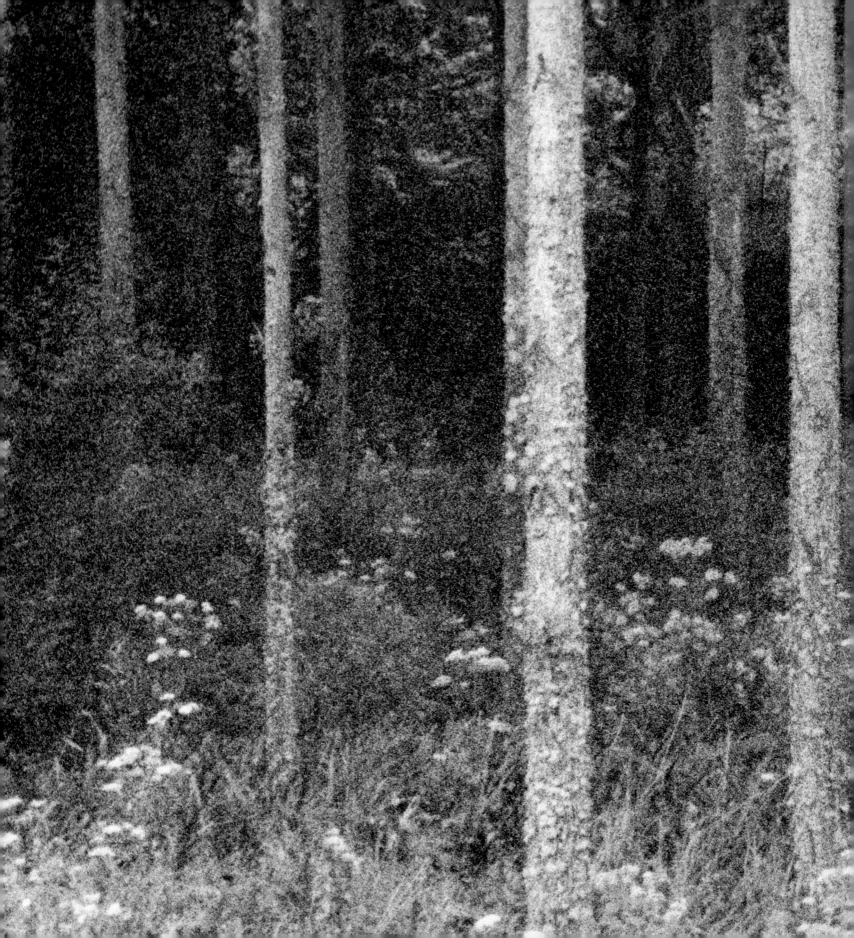

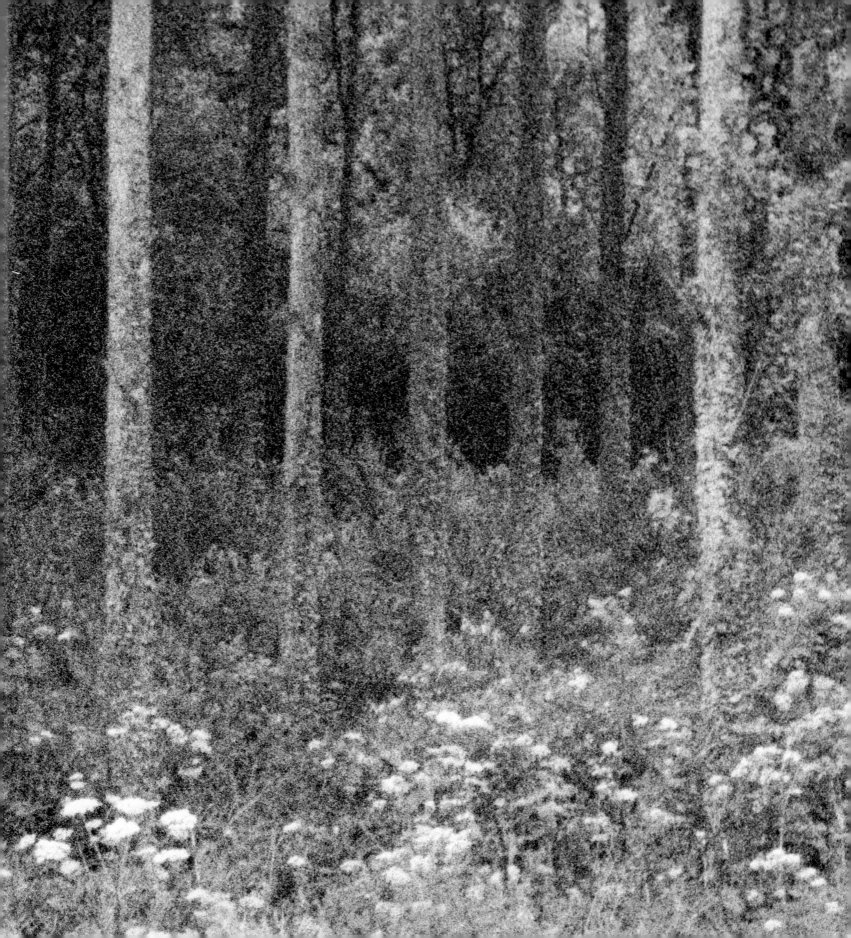

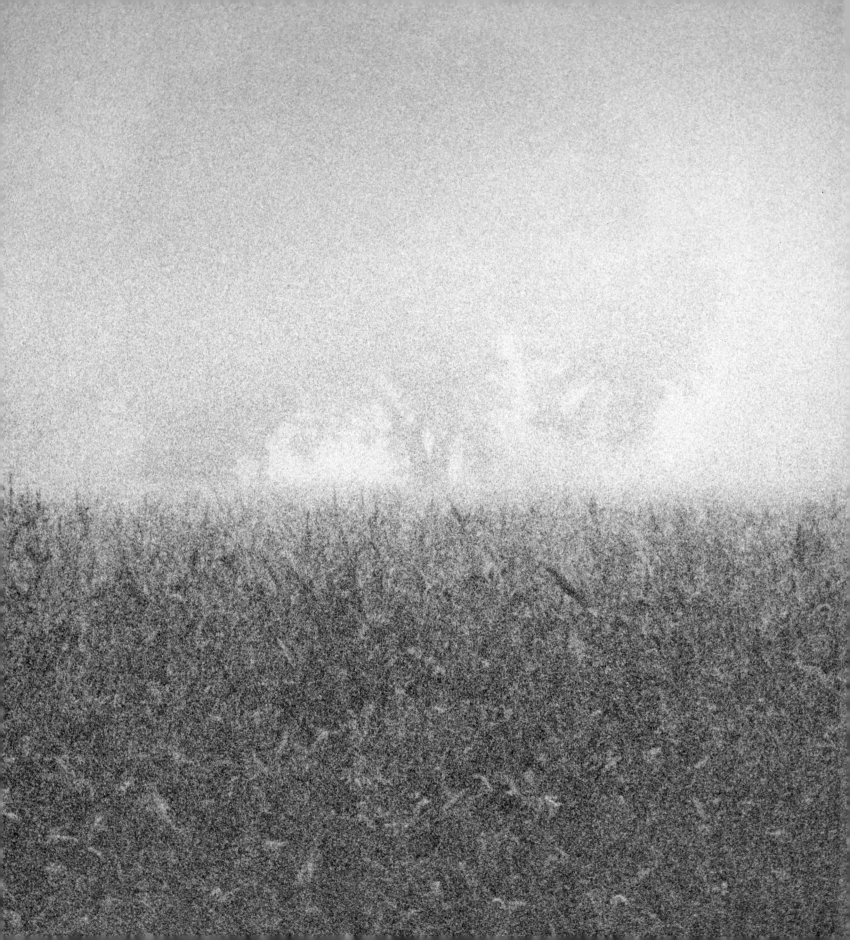

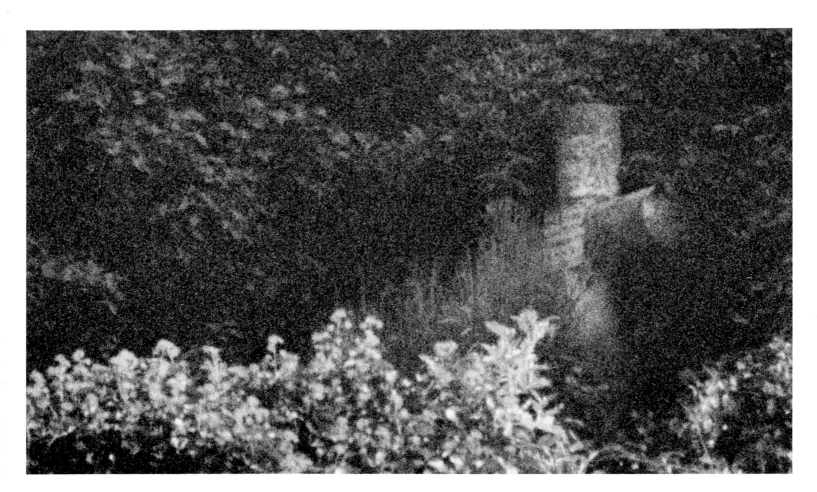

*Monet's grave, Giverny
churchyard*

Opposite:
*Field of maize near
Jeufosse, October*

THE PHOTOGRAPHS

PICTORIALISM IN PHOTOGRAPHY emerged as a movement in the late 1880s, as many photographers began to question whether the medium of photography did not offer a broader opportunity of expression than the conventional, straight photograph. Photographers, like others in the realm of arts and letters, became disillusioned with scientific, empirical investigation and sought to express artistic and spiritual truths with their art rather than produce direct observations from nature. Pictorial photographs, in which the pictured results are affected by the manipulation of the photographic process in either the picture-taking or printing stage, tend to resemble works in other mediums, particularly paintings, although they may not be made with this purpose in mind. Throughout much of this century, pictorialism in photography has been overshadowed by straight photography, but during the last decade there has been a new interest in a broad range of photographic techniques that produce expressive images beyond the reach of straight photography.

The photographs in this book were taken with a 17mm (110) camera using Eastman Kodak negative color film. The film was exposed and processed to achieve a maximum grain structure in the negative, and then enlarged and printed without manipulation of any kind. The extreme enlargement of a small negative produces images in which the grain structure of the film is visible. This has the effect of reducing the amount of detail in natural forms and breaking down their colors into discrete points. In a conventional color photograph, these points are so small that the eye blends them without perceiving them.